THE
HISTORY OF
WESTERN ART

ART ESSENTIALS

THE HISTORY OF WESTERN ART

—

JANETTA
REBOLD BENTON

—

T&H

REX : INTERFEC
TVS : EST

CONTENTS

INTRODUCTION

This richly illustrated book offers a succinct study of the
most important works of architecture, sculpture and
painting in the Western tradition from prehistory to today.
Focusing on the *history* in art history, presentation of
information is thematic and chronological in relation
to contemporaneous events, accomplishments and
even disasters.

The twelve chapters are organized in four Parts.
Part One includes chapters on the antecedents of the
Western Tradition in Prehistoric, Mesopotamian and
Egyptian art, Aegean and Greek art, and Etruscan
and Roman art. The chapters of Part Two discuss
Early Christian and Byzantine art, Early Medieval and
Romanesque art, and Gothic art. Part Three's chapters
encompass Renaissance and Mannerist art, 17th-century
Baroque art, and 18th-century Rococo and Neoclassical
art. Part Four considers Romanticism, Realism,

Impressionism and Post-Impressionism, and earlier 20th-century art, concluding with later 20th- and early 21st-century art.

Every chapter includes a summary of the major historical developments of the period, touching on social structures, political organizations, religious beliefs, scientific advances and customs. An exploration of these themes interwoven with the visual arts demonstrates that creative works simultaneously shape, reflect and document the culture of their time and place. A secondary focus views the constantly evolving aesthetic preferences as akin to a pendulum that swings between naturalism, idealism and abstraction, each era and style either rebelling against the previous or seeking to improve it.

Each chapter opens with a question for the reader to ponder and, hopefully, discuss.

PREHISTORIC THROUGH ANCIENT ROMAN ART

-

Early cultures create the foundation
for important future accomplishments
in art and architecture

-

Antecedents of the Western Tradition:
Prehistoric, Mesopotamian and Egyptian art
Can art aid in promoting stability in a culture?

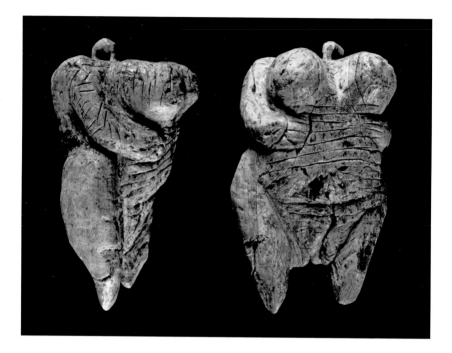

PREHISTORY

The earliest indications of anatomically modern homo sapiens in
Europe date to c.43,000–41,000 BCE, during the late Paleolithic
era (Old Stone Age), and are found mainly along the Mediterranean
coast. Small units of nomadic families followed game, built
temporary dwellings and used caves for shelter. Gradually, these
groups became more effective in combining hunting with gathering
food from their surroundings. During the relatively short Mesolithic
era (Middle Stone Age), life adapted to warmer climates and
permanent settlements appeared. The introduction of widespread
farming and the domestication of animals c.10,000 BCE mark the
beginning of the Neolithic era (New Stone Age).

Early burial practices imply some level of spirituality or religious beliefs

Evidence survives from prehistoric times of an interest in music (bells, flutes and whistles) and art (small sculptures, cave paintings and arrangements of stones). The oldest known sculpture of a human in Western art, the so-called *Venus of Hohle Fels* (opposite), named for the cave in southwestern Germany in which it was found, was made c.38,000–33,000 BCE. The head is no more than a knob; this is not a portrait of a specific individual but an embodiment of an idea or concept. The extremely enlarged breasts and vulva seem to associate this figurine with female fertility. Most prehistoric sculptures known today portray nude full-bodied female figures, often distorted rather than accurately proportioned. Referred to as Venus figurines, a modern nomenclature, their emphasis seems to be on procreation. However, another opinion claims these early figurines, small enough to fit in the palm of a hand, are prehistoric pornography.

Among the earliest paintings discovered in Europe are those in Chauvet Cave in southeastern France (below), where some images may date to as early as c.34,500 BCE whiles others were apparently added as recently as c.28,000 BCE. Explanations proposed for the meaning and purpose of the early cave paintings vary greatly. The images may have served as symbolic aids to the hunters. Spears, painted and actual, on the animals, with some shown to bleed as a result, support the theory that the painters believed to kill an animal

Anonymous carver
Venus of Hohle Fels,
side and front views,
c.38,000–33,000 BCE
Woolly mammoth tusk
ivory, h. 6 cm (2⅜ in.)
Urgeschichtliches
Museum, Blaubeuren,
Germany

The piercing of the tiny head suggests this figurine was worn as an amulet. She has been compared to the similarly abstracted *Venus of Willendorf*, found in Willendorf, Austria, dated c.24,000–22,000 BCE.

Prehistoric artists
Chauvet Cave, near
Vallon-Pont-d'Arc,
France,
c.34,500–28,000 BCE

These images, drawn from memory, are sufficiently naturalistic to make the specific species identifiable today.

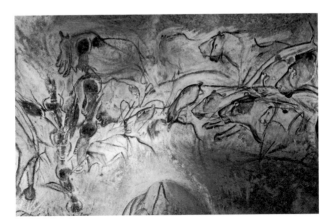

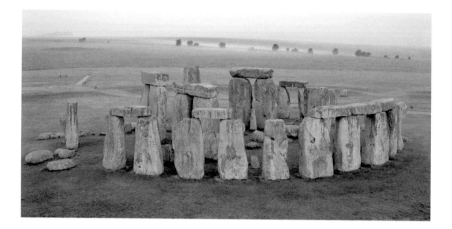

in effigy before the hunt might improve success in the actual hunt. Similarly, handprints on the animals may imply the hunter will grasp (and eat) the animal. Alternatively, as handprints are found throughout the caves, not only on the animals, perhaps they suggest authorship, akin to a signature prior to the invention of writing. Painting the animals deep within 'the womb' of Mother Earth may have been thought to increase the herd and hence improve the possibility of a favourable outcome to the hunt. Rendering these animals in paint may have given the artists a sense of control over their world.

Chauvet Cave contains depictions of a variety of animals – including lions, leopards, rhinos, bison, bears, deer and hyenas – rather than humans. The animals are carefully observed and their identifying features recorded. A profile view, including four legs, was favoured. However, no purposeful organization or composition is evident and animals overlap one another seemingly at random.

The most famous example of prehistoric architecture in the West is Stonehenge (above), located on Salisbury Plain in southern England, built beginning c.3100 BCE as a circular ditch and embankment, then repeatedly augmented and modified until c.2000 BCE. The outer circle is sarsen while the inner, lower circle is bluestone; neither type of stone occurs nearby. The origin of these **megaliths** (huge stones) and how they were transported and erected remain subjects of debate. Stonehenge is a **cromlech**, which is a circle of **menhirs** (megaliths set vertically into the earth), using **post and lintel construction** in which vertical posts support horizontal lintels, here the stones locked into place with a mortise and tenon system. Other prehistoric megaliths are found in several locations in western Europe and are likely to be associated with burials.

Anonymous builders
Stonehenge, Salisbury Plain, Wiltshire, England, completed c.2000 BCE
Sarsen and bluestone, h. outer circle stones 6.09 m (20 ft)

Stonehenge is located in an area rich in prehistoric sites, including Avebury Henge.

Stonehenge served as a cemetery. Other possible uses – such as those involving aliens – are controversial and vary in plausibility. Suggestions include a religious site, a place for commemorative ceremonies such as ancestor worship or ritual healing, perhaps a memorial or an observatory. The most persuasive explanation is that Stonehenge served as a huge sun clock because the placement of certain stones relates to the rising sun in the summer solstice and the setting sun in the winter solstice.

MESOPOTAMIA

The name Mesopotamia derives from the Greek for 'land between two rivers', based on its location between the Tigris and Euphrates Rivers (in present-day Iraq). Mesopotamia, the Levant and Lower Egypt together are called the Fertile Crescent because they form an arc shape. This region was among the earliest to domesticate animals and plants. Due to its central location, Mesopotamia was important to the trade network throughout the eastern Mediterranean Sea. More than goods were exchanged by these commercial activities; ideas, culture, philosophies and religious beliefs, languages, technology and law were transmitted and shared throughout the region. Statues from Egypt have been found in Mycenae, pottery from Crete in Egypt and Tyrian purple (a product unique to Phoenicia) throughout the Mediterranean.

Sumerian art

The earliest significant cities in Sumer in southern Mesopotamia appeared c.5000 BCE. The Sumerians receive credit for inventing the wheel, the sail and, c.3000 BCE, cuneiform writing. Increased population density led to a hierarchal social organization. Originally Sumer was comprised of many independent city-states, several with populations greater than 10,000, each with its own god and ruler. In c.2334 BCE Sargon of Akkad created a centralized dynastic empire by conquering several of his neighbours. Control of the region changed hands frequently. During a period of relative independence for the city-states of the region, Prince Gudea (overleaf) ruled the city-state of Lagash (r. c.2144–2124 BCE). He promoted Sumerian artistic accomplishments, as well as his own glory, by constructing temples and adorning them with sculptures of his likeness.

The majority of Sumerian sculpted figures seem to have been made for temples, but rather than being representations of deities, they were votive figures of worshippers (usually male), praying *in absentia*. Sumerian figures display a distinctive style of geometric

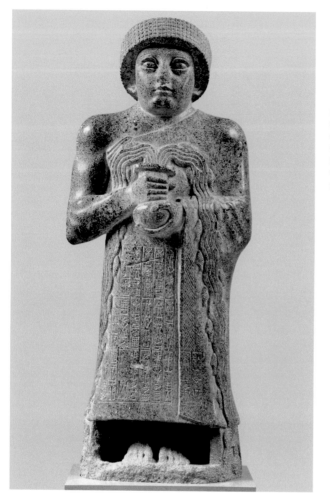

Sumerian sculptor
Gudea, from Tello, Sumer,
c.2120–2110 BCE
Dolerite, h. 62 cm
(24⅜ in.)
Musée du Louvre, Paris

**Prince Gudea of Lagash
had statues of himself –
shown as young and
muscular – placed
throughout his city-state,
an early example of art
used to enhance political
power.**

symmetry, rigid and stiff, with squat proportions, broad hips and
heavy legs. Sumerian faces have abnormally large, staring eyes
topped by a monobrow.

Babylonian art

During the 18th century BCE, King Hammurabi (r.1792–1750 BCE)
expanded the small Babylonian kingdom to include the Sumerian
and Akkadian city-states. Hammurabi deserves credit for
creating an important law code which, although longer and more
clearly structured than its predecessors, follows their general
arrangement. The 282 laws, organized into several sections,

concern issues still litigated today including false statements; personal property; land and house ownership; trade and commerce; family relationships; assault; and labour. Certain crimes resulted in specific penalties, often severe. The large stone **stele** on which the code is inscribed (below) is simultaneously an historical record of Babylonian law and a work of art. The relief portrays Hammurabi receiving the laws from Shamash, the god of justice and truth; thus, Hammurabi's code comes from the highest authority. Empowered by demonstrated divine sanction, Hammurabi's laws superseded those of earlier rulers.

Babylonian sculptor
Law Code of Hammurabi,
c.1760–1750 BCE
Basalt, h. 2.25 m
(7 ft 5 in.)
Musée du Louvre, Paris

Shamash holds the staff and ring that represent justice in his right hand, which he extends to Hammurabi.

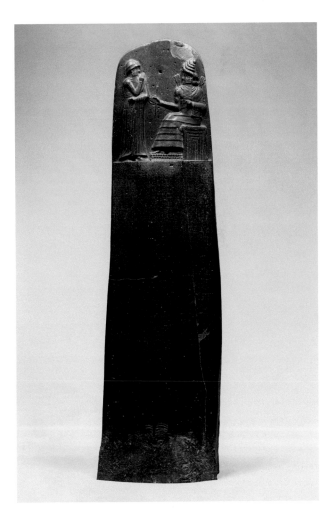

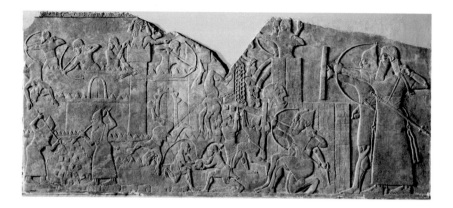

Assyrian art

After Hammurabi, Babylon's power gradually diminished and the
Assyrians to the north came to rule much of Mesopotamia. The
Assyrian focus on battle and conquest appears in their art (above).
In the first half of the 9th century BCE, Ashurnasirpal II (r.883–
859 BCE), known for his ferocity, expanded Assyrian hegemony
over Mesopotamia and into Anatolia and the Mediterranean coast.
He also created the new capital city of Nimrud on the River Tigris
and constructed buildings throughout his territory.

Assyria's large-scale stone **relief** panels often combine
documentation of military history with glorification of the ruler. The
scene of *Ashurnasirpal II Besieging a City* records images of weapons,
clothing and, in the lower left, looters taking the spoils of war. The
setting is parallel to the picture plane and all figures and faces are in
profile, flattening the effect. The relative size of a figure indicates
status in the social hierarchy rather than position in space. Due
to their usefulness in conveying information, such pictorial devices
also appear in Egyptian art and were perpetuated in the West.
The Assyrian Empire fell at the end of the 7th century BCE.

Assyrian sculptor
*Ashurnasirpal II Besieging
a City*, from the Palace
at Nimrud, Assyria,
first half of the 9th
century BCE
Gypsum relief
British Museum, London

**The series of narrative
reliefs from Nimrud are
comparable to scenes in
a play or chapters in a
book that chronicle
actual events.**

EGYPTIAN ART

Civilization developed along the River Nile c.5000 BCE, gradually
coalescing into Upper Egypt (the southern portion) and Lower
Egypt (the northern portion and delta), so named because the
Nile flows from south to north. The river provided transportation
for goods, people and ideas, encouraging a homogeneous culture.
The surrounding deserts offered protection from invasion. By
c.3200 BCE, the fertility of the Nile valley produced agricultural
surpluses that permitted the organization of society into an agrarian

class tied to the land, an artisanal class and a ruling elite. Family dynasties controlled Upper and Lower Egypt with tightly structured, centralized civil and religious bureaucracies.

Upper and Lower Egypt were united c.3100 BCE by Narmer, the first pharaoh of the first dynasty, whose accomplishments are recorded on the *Palette of Narmer* (below). Artistic conventions that would persist through Egypt's three millennia are already evident here; maximum information is conveyed clearly by using standardized narrative devices. For example, ideas are separated into **registers** by horizontal bands; physical size indicates a person's importance; each part of the body is depicted from its most readily recognizable point of view; an item shown above another means it is behind it; and much more.

Several of these conventions spread to the West, including the Mesopotamian/Egyptian depiction of the body from more than one viewpoint simultaneously. Greek vase painters would similarly show the head from the side but the eye from the front, legs from the side but chest from the front. The Mesopotamian/Egyptian equation of size and significance would become standard in Western medieval art.

Egyptian artist
Palette of Narmer,
front and back,
from Hierakonpolis,
c.3100 BCE, 1st dynasty
Siltstone, c.64 x 42 cm
(25¼ x 16½ in.)
Egyptian Museum, Cairo

This historical record of the unification of the two Egypts is also a palette for grinding paint in the central circular depression.

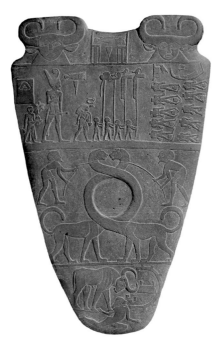
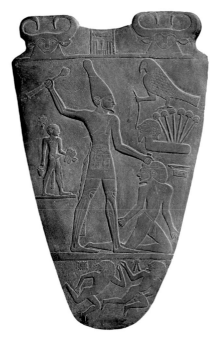

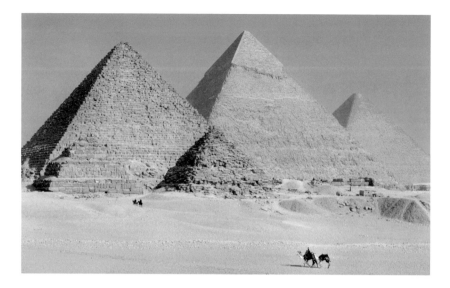

Ancient Egypt's history is divided into a pre-dynastic period followed by thirty or thirty-one dynasties. The three major periods of prosperity are referred to as the Old Kingdom, Middle Kingdom and New Kingdom, followed by a late period. This long history ends with Egypt's conquest by Alexander the Great, King of Greek Macedon, in 332 BCE.

Egyptians believed the soul or essence of each person, the *ka*, and their personality, the *ba*, survived indefinitely if the physical body was preserved. Consequently, preparing for the afterlife was a major focus of this life, especially for rulers, their families and top officials. The permanence of the Old Kingdom pyramids, mummification of the dead and burial with items for use in the next world accommodate the Egyptian concept of the afterlife. The Great Pyramids (above), tombs for three pharaohs on the west bank of the River Nile at Giza, are built of limestone blocks cut from east bank cliffs and floated across when the river flooded. The corners of the pyramids point precisely north, south, east and west. The builders calculated the dimensions with mathematical precision: the ratio of the base width to the height of each pyramid is eleven to seven. Corridors through the solid stone construction lead to the actual burial chambers within the pyramids.

Middle Kingdom rulers also built pyramids, but used sand and rubble fill rather than solid stone interiors. Over the centuries, theft of the limestone slabs that covered the structures exposed the interiors to gradual deterioration.

Anonymous builders
Great Pyramids, Giza, c.2550–2490 BCE, 4th dynasty, Old Kingdom
Limestone

Built for pharaohs Cheops, Chephren and Mycerinus, these pyramids display the pharaohs' power and provide assurance of their lives in the next world.

In the Old and Middle Kingdoms, the treasures buried with the deceased proved irresistible to grave robbers. Consequently, in the New Kingdom, the body rested in one place and a mortuary temple stood in another. For example, Pharaoh Hatshepsut's burial was in a rock-cut tomb in the Valley of the Kings behind Deir el-Bahri, Thebes, but her elaborate funerary temple, built c.1478– 1458 BCE during the 18th dynasty, abuts a nearby cliff. The architect Senmut (Senenmut) designed the temple, which included many sculpted images of Hatshepsut.

Egyptian sculptors depicted the human figure in one of four poses: standing with one foot forward (below); sitting on a block; cross-legged on the floor (less common); and kneeling on both knees (rare). These poses, established in the Old Kingdom, persisted with only minor modification for three millennia.

Egyptian sculptor
Pharaoh Mycerinus and his Queen, perhaps Khamerernebty II, from Mycerinus's Valley Temple, Giza, c.2548–2530 BCE, 4th dynasty, Old Kingdom
Greywacke,
142.2 x 57.1 x 56.2 cm (56 x 22½ x 22¼ in.)
Museum of Fine Arts, Boston

This is believed to be the first pair statue and to have introduced a style for depicting the royal couple together. The Queen affectionately embraces the King.

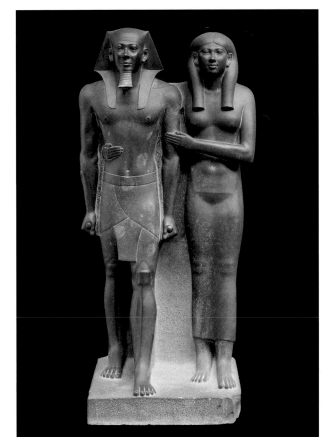

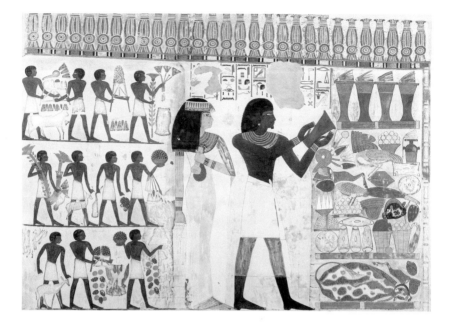

Tradition was favoured over innovation in ancient Egypt

Pharaoh Mycerinus and his Queen (previous page) display characteristics of all Egyptian standing figures. They are rigidly erect with one leg forward, yet their weight rests equally on both feet, rendering the figures immobile. The web between the figures, their arms and their bodies, and their legs prevents breakage as permanence was extremely important. Both are idealized, with individual characteristics minimized to suggest power and immortality.

In addition to the mummified body and items for use in the afterlife, the tomb contained a sculpted likeness of the deceased as a precaution against having no home for the *ka* if something happened to the mummy. To assure an enjoyable afterlife for the deceased, reliefs and paintings decorated the interiors of Egyptian tombs – works of art never intended for the eyes of the living. A painting of *Nakht and Lady Tawy Offering* (above), from the late 15th or early 14th century BCE, in an 18th-dynasty tomb at Thebes, is characteristic of Egyptian painting. Conveying information with clarity is still of greater importance than naturalistic representation. Indeed, Egyptian art does not portray what the eyes see, but what the mind knows is there. Continuing to favour condensation and

Egyptian artist
Nakht and Lady Tawy Offering, from the Tomb of Nakht, Thebes, c.1410–1370 BCE, 18th dynasty, New Kingdom
Wall painting
Metropolitan Museum of Art, New York

Although not a pharaoh, a high-ranking official like Nakht received a lavish burial.

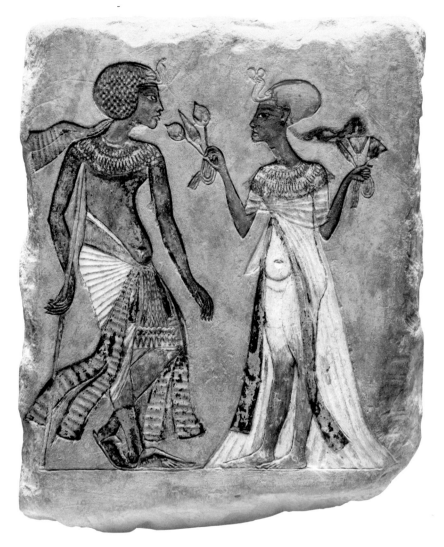

Egyptian artist
Royal Couple, perhaps
Akhenaten and Nefertiti
Amarna period style,
c.1335 BCE, 18th dynasty,
New Kingdom
Limestone relief
with pigment,
24.8 x 20 x 6.5 cm
(9¾ x 7⅞ x 2½ in.)
Neues Museum, Berlin

The only notable
deviations from the
characteristic continuity
of Egyptian life were
the changes – political,
religious and artistic –
instituted by Akhenaten
in the 18th dynasty.

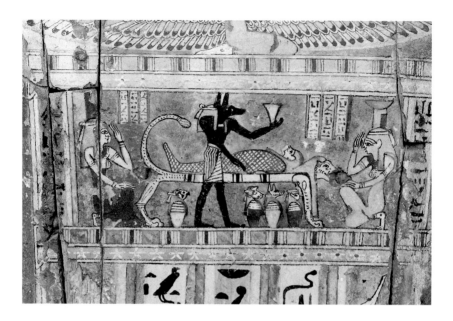

abbreviation, the artist depicts each part of the human body in the same way as seen on the *Palette of Narmer* (page 17), dated c.3100 BCE and thus carved approximately 1,700 years earlier. Both Nakht and Tawy have youthful ideal proportions.

Paintings on tomb walls document connections between the Egyptian and Aegean cultures. Aegeans are shown bearing gifts and paying tribute to the pharaoh in the tombs of Egyptian officials from the time of Thutmose III (r.1479–1425 BCE) and Amenhotep IV (r.1353–1336 or 1351–1334 BCE).

An important break with the past occurred during the 18th dynasty when Amenhotep IV replaced the entire Egyptian pantheon with the sun god Aten, changed his own name to Akhenaten and moved the capital from Thebes to Tell el-Amarna. He abandoned the traditional formal art for a more naturalistic style. The couple depicted on the previous page, perhaps Akhenaten and his wife Nefertiti, are shown with their familial physical deformities, thought to result from the Egyptian custom of inbreeding among royalty.

After the death of Akhenaten, Egypt reverted to the old polytheistic religion, the capital returned to Thebes and many of his changes in art disappeared.

Throughout Egypt's long history, the importance of the afterlife, and proper preparation for it, persisted. The complex

Egyptian artist
Embalming Scene,
c.400 BCE, 27th–
31st dynasty, New
Kingdom
Detail of painted wood
sarcophagus
Allard Pierson Museum,
Amsterdam

Anubis, god of embalming and protector of the ka on its journey to the afterlife, attends to the body of the deceased. Beneath the lion-shaped bier stand the four canopic jars, each topped with an effigy of one of the four sons of the god Horus tasked with protecting the internal organ within.

procedure of **mummification** involved drying and chemically treating the body to prevent decay (opposite). By removing internal organs to preserve them separately, embalmers had the opportunity to observe them closely. Ancient Egyptians made no clear distinction between the professions of priest and doctor as we think of them today. The treatment of the body and organs after death reflects this in that the organs were preserved for their spiritual significance as much as their physiological function. Although the liver, lungs, stomach and intestines were protected in canopic jars, the brain was not required for the afterlife and was simply pulped and extracted through the nostrils using a sharp hook.

In Egyptian death ceremonies, the heart, believed to be the home of the *ka*, received the greatest attention. It was either left in place or extracted, embalmed, protected by religious rites and amulets, then returned to the body cavity before bandaging. Embalmers observed many 'channels' connecting all parts of the body back to the heart. Some (now recognized as veins) contained blood while others (arteries) appeared to contain only air. Consequently, ancient Egyptian physicians deduced that the heart was the well from which blood, water and air flowed to supply the body. This made a neat analogy between the human body and the land of Egypt: just as blocked irrigation channels from the Nile would cause crops to become sickly and fail, so too blocking the body's channels would lead to disease.

Artists were key to Egyptian burial practices. The sculptors' skills were needed to create the canopic jars, while the painters' abilities were required to decorate the sarcophagi with images and writing. The embalming scene demonstrates the Egyptian preference for animal imagery for their deities, canopic jars and even furniture.

Aegean and Greek art
Which ideas originated by the ancient Greeks continue to influence us today?

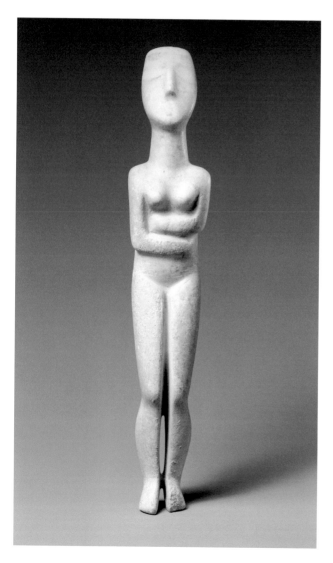

Cycladic sculptor
Female Figure,
Cycladic,
c.2700–2600 BCE
Marble, h. 37.1 cm
(14⅝ in.)
Metropolitan Museum
of Art, New York

Although we may be inclined to think of abstraction as a recent artistic trend, Cycladic figures, almost abstract in their minimalist design, date back to the third millennium BCE.

AEGEAN AREA

Civilization developed throughout the area of the Aegean Sea prior to the Neolithic Era. Between c.3000 and 1100 BCE, three cultures dominated sequentially: the Cycladic centring on the Cycladic islands, the Minoan on the island of Crete and the Mycenaean on the Greek mainland.

Cycladic art

The Cyclades include 220 islands in the Aegean Sea. Little is known about this culture, apart from their art objects. Many marble figures (opposite), made in the third and second millennia BCE, most only a few inches tall but several life size, have been discovered in Cycladic tombs, suggesting they were part of funerary practices. The majority are female, nude except for perhaps an indication of a necklace, arms folded across their abdomens and their straight legs together. However, the position of the feet does not allow the figures to stand; instead, they appear to be designed to recline on their backs, perhaps as representations of the major deity in the Aegean area – the Mother Goddess who brought fertility.

Characteristically Cycladic is the figures' simplified abstracted anatomy. Their distorted proportions vary but the pose does so only rarely. Facial features may be indicated with paint or relief – especially the notable nose. The Cycladic Islands prospered until the mid-second millennium BCE.

Minoan art

Crete, largest of the Aegean islands, had been settled as early as c.7000 BCE. By 1900 BCE, palace complexes had risen at Knossos and elsewhere. Around 1700 BCE, a major disaster, thought to have been either an earthquake or an invasion, destroyed many of the palaces – which the Minoans then rebuilt on an even grander scale. The name Minoan derives from a 19th-century association of the palace at Knossos (overleaf) with the legend of King Minos, the Minotaur and the labyrinth.

The Palace of Minos at Knossos was repeatedly rebuilt and expanded from 1700 to 1300 BCE, until it consisted of between 1,300 and 1,500 rooms on several levels of ground and several storeys high, without an obvious organization. The palace had good plumbing and flushing toilets. Minoans built with inverted columns made from upside-down painted tree trunks. The simple cushion-shaped capitals are akin to those of the earliest Greek Doric temples. Murals embellished the palace walls. Protected by their

Minoan builders
Palace of Minos,
Knossos, Crete,
c.1900–1300 BCE

**Minoan palaces, open
to the island breezes
and constructed with
characteristic inverted
columns, offered
colourful luxury.**

island location, the Minoans built palaces rather than fortifications. Correspondingly, artists rarely depicted militaristic themes.

Evidence of trade between Crete and the Cycladic islands, the Greek mainland (especially Mycenae), Anatolia and Egypt proves the Minoans were skilled sailors. Minoan culture began to decline around 1450 BCE and eventually the Mycenaeans took control of Crete.

Mycenaean art

As the power of the militaristic Mycenaeans grew, their trading activity fostered wide-reaching economic expansion. Much like the Minoans, the Mycenaeans formed separate palace-centric states, the entire culture taking its name from its most important site at Mycenae. Although the Mycenaeans conquered the Minoans, Minoan art influenced that of the Mycenaeans.

The Lion Gate (opposite), built c.1300–1200 BCE, provided access to the city of Mycenae. Made of huge stones, the lintel is surmounted by a **relieving triangle**, the opening filled by a thin slab of limestone carved with symmetrical rampant lions flanking a Minoan inverted column. Mycenaean influence in the Aegean area ended by c.1100 BCE.

Greek art

The mainland Greeks developed a major culture that is historically divided into several periods: Geometric (c.1000–700 BCE), Archaic (c.700–480 BCE), Classical (c.480–323 BCE, the death of Alexander the Great) and Hellenistic (323–31 BCE, the victory of the Roman emperor Augustus over Cleopatra).

The term Geometric describes the style of the painting and sculpture of the era. Geometric vases are painted with horizontal bands and geometric shapes such as circles and zigzags. Humans and horses, in turn, have triangular torsos with pinched waists. The same physique appears on small metal and ivory figurines. The Greeks' quest for perfection in the visual arts parallels their quest for physical perfection, demonstrated by the Olympic Games, held every four years from 776 BCE to honour the god Zeus.

During the Archaic period, villages consolidated into geographically defined city-states or poleis. The population expanded to establish colonies throughout the Aegean area, into

Mycenaen builders
Lion Gate,
c.1300–1200 BCE
Limestone
Mycenae

Masonry of such proportions is referred to as Cyclopean, the name deriving from the idea that only the mythological one-eyed giant Cyclops could have moved these megaliths.

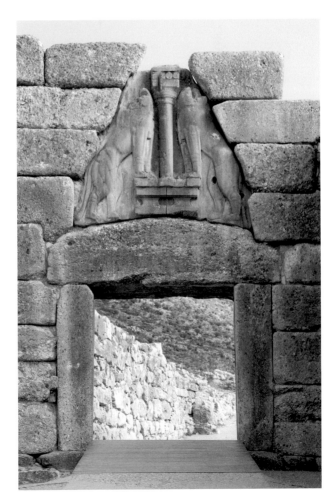

mainland Italy, Sicily and beyond. The independent poleis were highly competitive, with differing political systems ranging from kingdoms (Sparta) and oligarchies (Corinth) to democracies (Athens).

Greek painting survives on ceramics. The most significant techniques, referred to as **black-figure** and **red-figure**, developed during the Archaic period. Both centred in Athens, giving that city dominance in vase manufacturing. The black-figure technique began mid-7th century BCE and achieved its highpoint during the 6th century BCE. The artist painted the forms with black glaze on the natural orange clay of Attica. A pointed tool was used to make details by scraping through the glaze. The **amphora** (a two-handled vessel) seen below and opposite, portrays *Herakles Resting on a Couch* in both black-figure and red-figure.

Andokides Painter
Herakles Resting on a Couch,
c.520–510 BCE
Archaic bilingual vase, black-figure side,
h. 53.5 cm, w. 22.5 cm
(h. 21 in., w. 8⅞ in.)
Staatliche Antikensammlungen, Munich

Andokides Painter
Herakles Resting on a Couch,
c.520–510 BCE
Archaic bilingual vase,
red-figure side,
h. 53.5 cm, w. 22.5 cm
(h. 21 in., w. 8⅞ in.)
Staatliche
Antikensammlungen,
Munich

Subjects from mythology and everyday activities were featured on Greek ceramics.

An influx of people from Asia Minor brought Eastern and Ionian influences to mainland Greece c.530 BCE. Their arrival coincides with the start of **red-figure** painting (below), which gradually replaced black-figure, the transition complete c.500 BCE. This unusual vase, combining black-figure and red-figure, therefore referred to as bilingual, indicates the transition between the two. Technically, red-figure is a reversal of black-figure: the background is painted black, leaving the figures in the orange clay. A tiny brush is used to paint details that are therefore more flowing than when scraped in black-figure.

Images of the human figure dominated both painting and sculpture. In an important change from the Geometric period, thought to be due to contact with Egypt, Archaic sculptors introduced life-size stone figures as well as the specific pose with

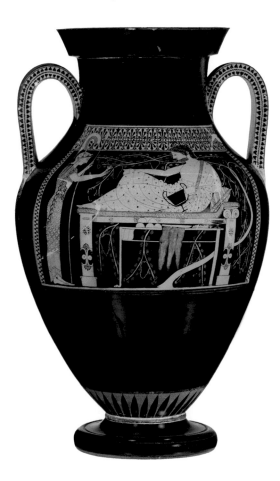

the left foot forward and arms close to the sides. The male **kouros** figures (plural: **kouroi)** are nude while the female **koré** figures (plural: **korai**) are dressed. These sculptures were used as gifts to the gods and as grave markers. An example known as the *New York Kouros*, in the Metropolitan Museum of Art, New York, carved c.590–580 BCE, resembles Egyptian standing figures such as those illustrated on page 19. Archaic korai wear the Doric peplos, a style of dress belted at the waist and made of thick fabric that obscures the shape of the lower body. Some korai are accessorized with earrings, necklaces and bracelets. Towards the end of the 6th century BCE, women's fashion changed and the Doric peplos was replaced by the Ionic chiton, introduced to Athens from Ionia. The thin fabric of the chiton clings to the body with complexly draped folds, the hemlines embellished with decorative borders.

**Greek sculptures were originally painted,
but only traces of colour remain today**

Early kouroi and korai have a distinctive facial expression known as the Archaic smile. The eyes are enlarged and the hair creates a perfect, but unnatural, design. These are not portraits of specific recognizable people. Over time, figures became less stylized and more naturalistic.

The Classical period began 480 BCE with the defeat of Persia and the ascendancy of Athens, which vied with Sparta for leadership of the Greek world. Athens dominated c.480 until 404 BCE, when it lost the Peloponnesian war to Sparta and her allies.

The gradual increase in naturalness with which the human figure was portrayed during this time reaches a high point in the *Doryphoros (Spear-Bearer)* (opposite). The original bronze by Polykleitos, cast c.450–440 BCE, is known only through Roman marble copies. Polykleitos devised a set of rules to create perfect proportions for the male nude in which the height of the head served as the unit of measurement.

In contrast to the stiff pose characteristic of the earlier kouroi, the *Spear-Bearer* stands in the relaxed **contrapposto** (counterpoise) pose, first introduced in a tentative form c.480 BCE in the so-called *Kritios Boy* by the sculptor Kritios (Acropolis Museum, Athens). Several decades later the *Spear-Bearer*'s weight rests on only one foot, his hips and shoulders tilt as he sways naturally in space and the anatomy is accurate. The awkward Archaic smile is no more.

After Polykleitos of Argos
Doryphoros (Spear-Bearer), Roman marble copy of Greek bronze original, c.450–440 BCE, h. 2.12 m (6 ft 11 in.) Museo Archeologico Nazionale, Naples

The mid-5th-century BCE ideal seen here was eight heads tall, whereas the later, slenderer ideal was nine heads tall.

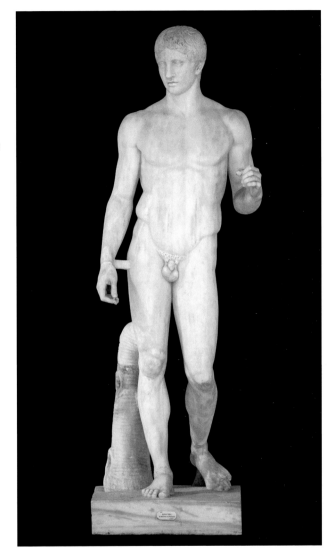

A slightly more animated contrapposto pose appears on the *Venus de' Medici* (overleaf), a copy of Praxiteles's 4th-century BCE *Aphrodite* or *Venus Pudica (Modest Venus)*, now known only through copies. Male figures were shown in the nude, but only much later were women similarly portrayed. Just as Polykleitos established an ideal canon of proportions for male figures, Praxiteles did the same for female physical beauty.

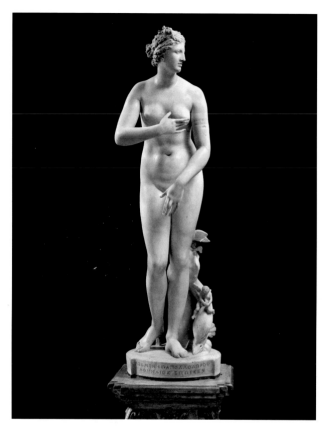

Roman sculptor
*Venus de' Medici
(Venus Pudica)*,
Late 2nd–early
1st century BCE Parian
marble copy of a bronze
original in the style of
the 4th-century BCE
Athenian sculptor
Praxiteles's *Aphrodite
of Knidos*, h. 153 cm
(60¼ in.)
Galleria degli Uffizi,
Florence

**The goddess is an
exemplar of the then-
current ideal of female
beauty.**

Continuing the increasing interest in animation, stone seems to
come to life in the Hellenistic era. The *Nike of Samothrace* (*Winged
Victory*), for example, carved of marble c.200–190 BCE (Musée du
Louvre, Paris), spreads her wings as she strides forward.

-

**Just as the human figure was portrayed according to
mathematically ideal proportions, the same approach
determined the dimensions of Greek temples**

-

The buildings on the Acropolis (literally 'high city') in Athens
were constructed in the second half of the 5th century BCE.
The celebrated Parthenon (opposite) is the masterpiece of the
architects Iktinos and Kallikrates. Phidias was in charge of the
sculpture, including a huge gold and ivory statue of *Athena
Parthenos*, now destroyed, that once stood in the interior.

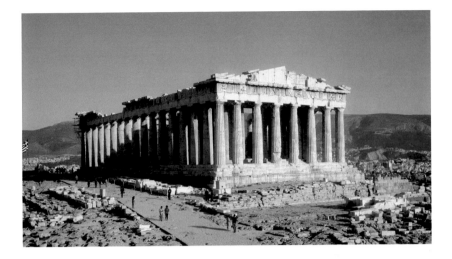

Iktinos and Kallikrates
Parthenon, Acropolis,
Athens,
constructed 447–
438 BCE, decoration
completed 432 BCE
Marble

**Literally and
figuratively the high
point of Classical
Greek architecture,
the Parthenon set the
standard of perfection
for future architecture.**

The visual appeal of the Parthenon comes largely from its proportions, which had been gradually perfected in earlier temples. In accord with the **Golden Section**, the ratio of width to height of the façade is approximately 8:5. Further, the Parthenon exhibits the so-called 'refinements', a series of specific and intentional irregularities. For example, both the platform and the entablature curve upwards in the centre. The surrounding columns (**peristyle**) have a visible swelling (**entasis**) in the shaft, which tapers towards the top. The corner columns are larger in diameter and positioned closer together than the others (corner or **angle contraction**), and the columns all tilt inward slightly. Although the refinements were previously thought to be intended to correct optical distortion, a more recent opinion proposes that they were to add beauty.

The three **orders** of architecture created by the Greeks are the **Doric**, **Ionic** and **Corinthian**. The Parthenon is a Doric temple. This was the oldest and simplest order and, among the three, the most favoured by Greek architects. The defining capital consists of an abacus (square block) and echinus (cushion-shape below). The slender Ionic is recognized by a scroll-shaped capital. Curling acanthus leaves identify the Corinthian capital. The most ornamental and delicate of the three orders, the Corinthian was used the least by the Greeks but the most by the Romans.

Etruscan and Roman art

Did art play a role in Rome's military expansion and its establishment of a vast empire?

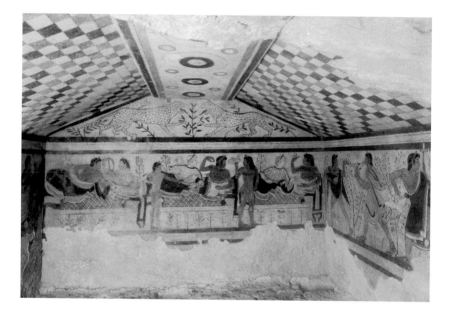

ETRUSCAN ART

In Italy, the indigenous Iron Age Villanovans developed into the Etruscan culture about the same time the Greeks entered the Archaic period. The area now called Tuscany was the Etruscan heartland. By the 8th century BCE, the Etruscans had established valuable relations with the Greek and Phoenician colonies in Italy, trading in iron, copper and pottery, and, through these contacts, absorbed cultural influences from Assyria and Egypt.

Relatively little is known about Etruscan religious architecture because only the stone foundations of temples survive. The upper portions, built from impermanent wood and mud brick,

have disappeared. Historians rely on a description by the ancient Roman architect Vitruvius to create hypothetical models. Heavily influenced by contact with Greek colonies, Etruscan temples are believed to have modified the Greek Doric order by adding a base to create the Tuscan order. Etruscan temples differed from the Greek in lacking a true peristyle, having an almost square plan, deep portico and steps only in the front.

What is known about the Etruscans comes largely from their funerary practices. Etruscan sarcophagi of the 6th century BCE suggest an optimistic outlook on the afterlife. A couple reclines comfortably on top of their couch-shaped sarcophagus from Cerveteri, made c.520–510 BCE of terracotta (Musée du Louvre, Paris).

Etruscan artist
Banqueting Scene, Tomb of the Leopards, Tarquinia, c.480–450 BCE
Wall and ceiling paintings

This scene supports the belief that Etruscan women and men shared comparable status.

Etruscan tombs were either corbelled stone domes covered by earth (at Cerveteri) or rock-cut rectangular rooms (at Tarquinia). Murals on the walls of the latter type indicate belief in an afterlife of pleasurable activities. In the Tomb of the Leopards (opposite), c.480–450 BCE, three couples recline as two naked men serve them. On the side walls, musicians provide entertainment. The Etruscans were considered by their Greek and Roman contemporaries to be rich and luxury-loving. As in ancient Egypt, women are shown with paler skin than men. Unlike Greek and Roman women, who were sequestered, Etruscan women appeared in public, feasted and drank with men, could inherit and own property and kept their names after marriage.

Especially notable is the Tomb of the Reliefs at Cerveteri because it mimics the appearance of a family home and thus provides an excellent document of daily Etruscan life. Painted reliefs depict various household tools as well as other items, and the burial niches even have pillows in this luxurious family mausoleum. The Tomb of the Reliefs is dated late 4th or 3rd century BCE. By the mid-3rd century BCE, Rome had absorbed Etruria.

ROMAN ART

Located on the River Tiber in central Italy, Rome began as a village of mud huts inhabited by shepherds and farmers (known as Latins) ruled by Etruscan kings. From its founding, Rome was heavily influenced by both Greek and Etruscan culture. After losses in wars with the Greeks in Italy, Etruscan power declined and that of Rome increased. Ancient Roman history is divided into the Kingdom (c.750–509 BCE), the Republic (509–27 BCE) and the Empire (27 BCE until 476 CE in the west and 1453 CE in the east).

Roman society, unlike Etruscan society, was highly patriarchal, the *pater familias* having absolute authority over his family, which was the basic social unit. In general, Roman women were to remain out of sight, chastely minding domestic chores, whereas Roman men were to participate in military and public affairs. Further, society was divided between slaves and non-slaves; between citizens and non-citizens; and, among citizens, between plebeians and patricians, according to birth.

The 1st-century BCE poet Horace wrote, 'Graecia capta ferum victorem cepit' (Captive Greece conquered her wild conqueror); although the Romans conquered the Greeks in battle, Greek culture dominated that of Rome.

The Romans turned to Greek artists and authors to establish cultural legitimacy

In fact, Roman writers praised Greek artists like Polykleitos, Praxiteles and Lysippos rather than Roman artists.

Yet Roman art was not solely a continuation or imitation of Greek art. In wall painting, Romans introduced images that were simultaneously decorative and deceptive. In sculpture, Romans created the first truly naturalistic portraits. In architecture, innovative Romans exploited the potentials of the arch principle and concrete construction.

Four styles of ancient Roman wall painting have been identified. The First Style, the Incrustation, dates 2nd century–c.80 BCE and consists of painted imitations of coloured masonry slabs. For example, at the Samnite House in Herculaneum, the painted imitation marble slabs emphasize the flat wall surface.

The Second Style, the Architectural, dates from c.80– 30/20 BCE. Actual architecture is mimicked in paint, as at the House of the Griffins on the Palatine Hill in Rome (opposite). In this display of wealth and status, fictive architecture embellishes an entire room. The solid walls disappear as the artist seemingly extends the dimensions of the room. The ancient Romans admired visual trickery: Pliny the Elder writes in his *Natural History* that a painting of roof tiles earned praise when crows attempted to alight on them.

The Third Style, the Ornamental, dates from the late 1st century BCE to the mid-1st century CE. Large areas are painted in a single colour – either red, black or white – emphasizing the flat wall surface. No painted vistas create three-dimensional

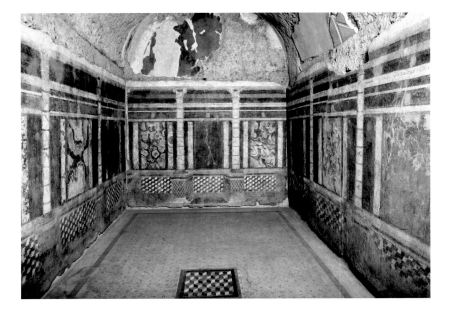

Roman painter
Cubiculum (bedroom)
from the House of the
Griffins, Palatine Hill,
Rome,
c.80–40 BCE, early
Second Style

**Most of what we know
of ancient Roman wall
painting comes from the
cities of Herculaneum
and Pompeii, preserved
by Vesuvius's eruption
(79 CE). The House of
the Griffins, however, is
one of several survivals
in Rome.**

illusions; instead, small painted frames contain scenes. Decorative architectural details, delicate floral motifs and figures add embellishment. The House of the Farnesina in Trastevere, Rome, is an example.

The Fourth Style, the Composite, popular from the mid-1st century CE to the eruption of Vesuvius in 79 CE, combines elements of the three preceding styles. Thus faux marble slabs, imitation architecture and small scenes surrounded by large areas of solid colours are all found in the Ixion Room of the House of the Vettii, Pompeii, 63–79 CE.

Although Greek murals do not survive, Roman murals are assumed to copy Greek models. It is certain that Greek sculpture influenced Roman sculpture. However, Greek statues depict gods and heroes, whereas Roman sculptors created images of specific individuals. The focus on naturalistic portraiture during the Republic is linked to the importance of family among the Romans, as shown by the late 1st-century BCE sculpture of *A Roman Patrician with Busts of his Ancestors* (Capitoline Museums, Rome). Further, the Roman Republic revered age as a virtue. Thus, sculptors recorded the inevitable changes that occur with the passing years (overleaf).

After years of civil strife, Augustus established the Roman Empire and reigned 27 BCE–14 CE. The *Augustus of Primaporta*

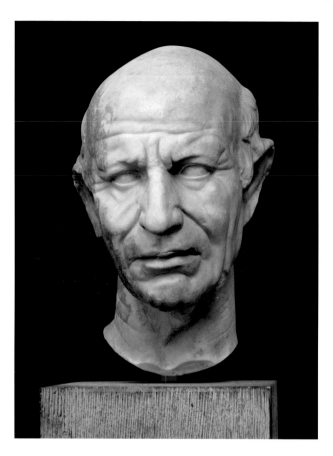

Roman sculptor
*Portrait of a Republican
Roman,*
c.70–60 BCE
Marble, life size
Glyptothek, Munich

**The wrinkles, loose
skin, hair loss,
physical irregularities
and imperfections
of old age were not
only recognized but
seemingly emphasized by
Republican sculptors.**

(opposite), carved c.20 BCE, coincides with a change in artistic style.
As Augustus imported more Greek artists, the Greek focus on
youthful idealism softened the stark Republican Roman portraits.
This is a recognizable, if somewhat idealized, portrait of Augustus.
The carving on the cuirass (breastplate) is a symbolic reference to
the *Pax Romana* (Roman Peace) that Augustus created.

Roman architects were strongly influenced by their Greek
and Etruscan predecessors. The rectangular Roman temple type,
such as the Maison Carrée in Nîmes, built in the earliest years of
the 1st century CE, derives from a merging of Greek and Etruscan
models. The Romans used the Greek Doric, Ionic and Corinthian
orders, along with the Etruscan Tuscan order, and created the
Composite order by combining the volute of the Ionic order with
the acanthus leaves of the Corinthian order. And Roman innovation
went much further.

Roman sculptor
Augustus of Primaporta,
c.20 BCE
Marble, h. 2.03 m
(6 ft 8 in.)
Braccio Nuovo, Musei
Vaticani, Rome

**This over life-size marble
figure glorifies the
emperor and Roman
peace under his rule.**

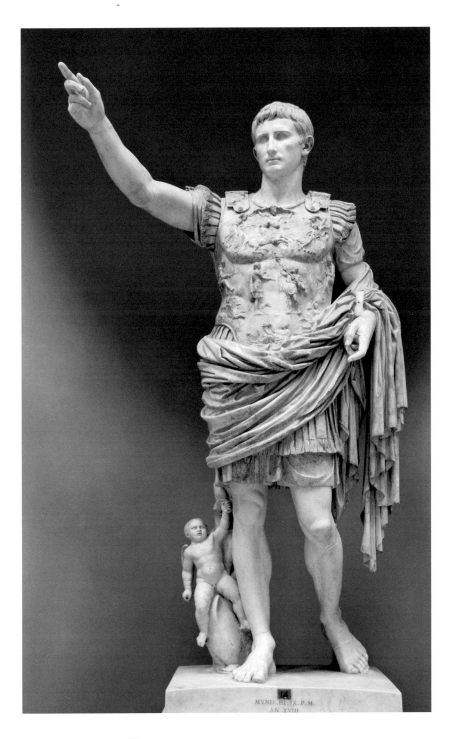

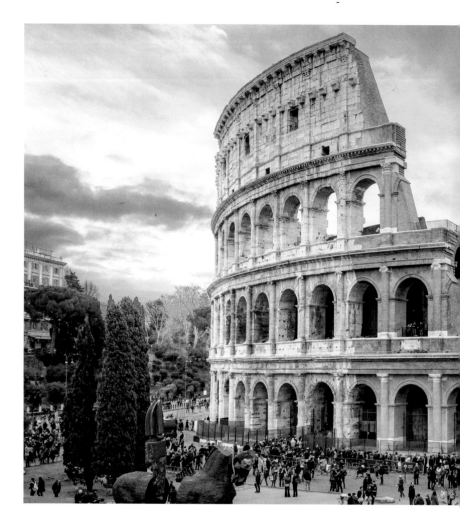

Many theatres, amphitheatres and arenas provided amusements and diversions for the people throughout the Empire. The Greek theatre was semi-circular in shape; the Romans doubled it, creating a round or oval structure. An amphitheatre is a theatre literally 'on both sides' (*amphi* in Greek). The Colosseum in Rome (above), completed c.80 CE, was the largest amphitheatre in the ancient world. More than 50,000 people could attend events while protected from Rome's strong sun by a movable awning. Spectacles included individual and group combat, imported animals and even staged naval battles.

Both concrete and the arch predate the Romans, but the Romans were the first to capitalize on their possibilities. The interior

Roman builders
Colosseum, Rome,
completed c.80 CE
Stone and concrete

Roman architects and engineers created extraordinary large-scale structures in which the government-sponsored entertainment expected by the Roman public was presented.

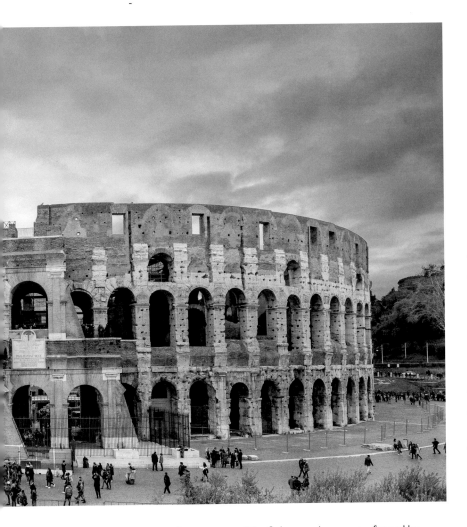

supporting structure of the Colosseum is concrete, formed by mixing cement with small pieces of stone, an excellent material to make strong walls quickly and inexpensively. The walls were faced with travertine and tufa (types of limestone), the stones held together by bronze clamps. On the exterior, engaged columns of three architectural orders are combined: the lowest level is the Tuscan order; above is the Ionic; and the third level is Corinthian. On the fourth the columns are replaced with piers, also Corinthian. Eighty arches around the Colosseum at ground level provide easy entry and exit for large numbers of people.

The Pantheon (overleaf), a temple dedicated to all the Roman gods, constructed 118–125 CE under Hadrian, is another important

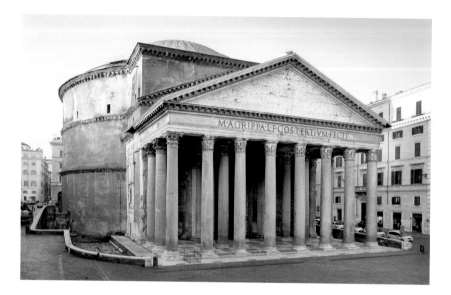

rounded building of ancient Rome. Designed by Apollodorus of Damascus, it is one of many temples built for the Romans' polytheistic religion. The original appearance was even more impressive when steps led up to the entrance and the porch was more extensive.

Apollodorus of Damascus
Pantheon, Rome, exterior,
118–125 CE

The Pantheon is still the world's largest unreinforced concrete dome.

Many later buildings would use the Pantheon as their model

The concrete dome makes it possible to enclose a vast space uninterrupted by interior supports. The height of the circular base below the Pantheon's hemispherical dome equals its radius, making the total height and diameter of the dome both 44 metres (144 feet). The **oculus** (eye) admits sunlight through an opening 9.1 metres (30 feet) in diameter at the peak of the dome. The **coffers** (squarish indentations) on the inner surface of the dome have lost their gold plating and bronze rosettes, but not their function of reducing the total weight of the dome.

Roman architecture was often combined with sculpture for decorative, documentary and/or commemorative purposes. Monumental columns and arches carved with narrative scenes to memorialize a military triumph are a Roman speciality. A series of military campaigns resulted in Rome's control of the largest empire ever created, reaching its greatest extent 117 CE under

Trajan (r.98–117 CE). Apollodorus of Damascus, architect of the
Pantheon, also designed the Column of Trajan in the Forum of
Trajan, Rome, 106–113 CE. Reading from the bottom to the top, the
reliefs document actual events with notable precision. Depicted are
Trajan's successful wars against the Dacians (present-day Romania),
101–3 CE and 105–7 CE.

The Romans were also victorious under Marcus Aurelius
(r. 161–80 CE) in the Marcomannic Wars along the River Danube
166–80 CE. Events from these wars appear on the Column of
Marcus Aurelius and the now-destroyed Triumphal Arch of Marcus
Aurelius, both in Rome. The freestanding bronze equestrian statue
of this emperor on the Capitoline Hill, Rome, has become a
standard way to immortalize military leaders. In this depiction,
Marcus Aurelius is unarmed to promote the idea of peace, for he
was a Stoic philosopher, gentle and wise.

The decline of the Roman Empire started with the reign of
Marcus Aurelius's son Commodus (r.180–92 CE), whose murder
precipitated internal conflicts. Twenty-five of the twenty-six
emperors who ruled between 235 and 284 CE were murdered,
leading to constant upheaval. In 324, Constantine gained control of
the entire Empire, and in 330 CE, he moved the seat of government
to Constantinople (formerly Byzantium, today Istanbul). Rome was
no longer the cultural centre of the Western world. Constantine
ruled until his death in 337. In 395, the Empire split into eastern
and western regions with co-equal emperors. In 476 the western
Empire, diminished by territorial losses to invading Germanic tribes,
was finally overrun.

KEY IDEAS

Prehistory: Images and architecture document life prior to
written records.

Mesopotamia: In Sumerian, Babylonian and Assyrian cultures,
art plays a role in establishing political power.

Egypt: Art and architecture reflect belief in an eternal afterlife.

Aegean: The Cycladic, Minoan and Mycenaean cultures share
influences.

Greece: In the Geometric, Archaic, Classical and Hellenistic
periods, the basics of Western art and architecture appear,
setting enduring standards.

Rome: Admiration for Greek art is combined with naturalistic
portraiture. The Pantheon and Colosseum are made possible
by the use of concrete and the arch.

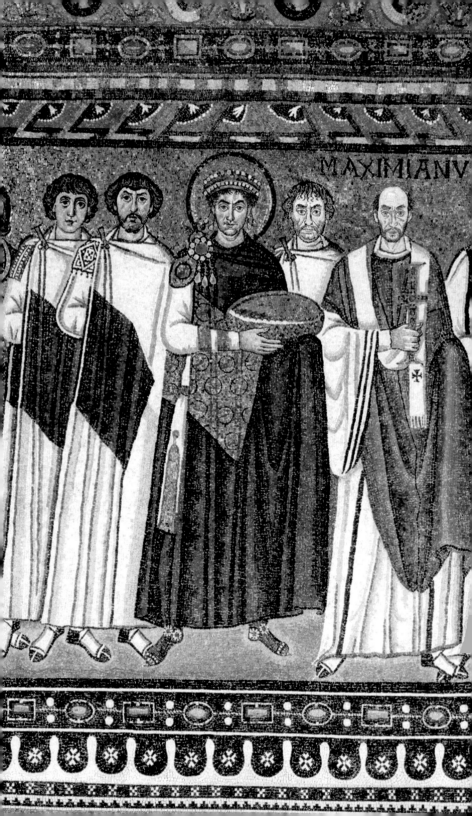
MAXIMIANV

EARLY CHRISTIAN THROUGH MEDIEVAL ART

-

Introduction of new subjects in painting and
new structural techniques in architecture
coincided with the rise of Christianity to
produce important aesthetic accomplishments

-

Early Christian and Byzantine art
How did the new Christian religion use art to further its position?

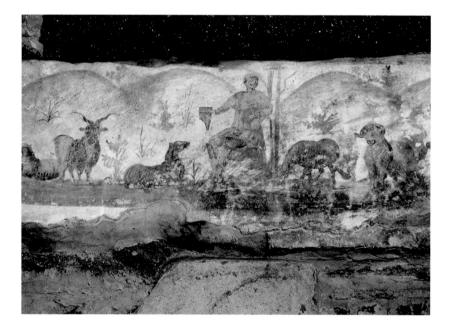

EARLY CHRISTIAN ART

Christianity quickly expanded throughout the Roman Empire from its origins in Judea. The first governmental sanction against the new religion was promulgated by the Emperor Nero in 64 CE, scapegoating Christians for the disastrous fire in Rome that year. Although there were periods of local persecution, religious tolerance was generally widespread in the Empire and Christians rose to positions of influence and power within the administration. However, in 250 CE, the Emperor Decius required all inhabitants of the Empire to sacrifice to the Roman gods, which was anathema to Christians. Between 250 and 313 there were several empire-wide persecutions of Christians, notably under the Emperors Valerian and Diocletian. However, the Edict of Milan, issued by the Emperor

Roman artist
The Good Shepherd,
Catacombs of Domitilla,
Rome,
3rd–4th century CE
Fresco

Jesus is shown as the shepherd who guides and guards his flock of faithful Christian followers.

Constantine in 313, reinstated tolerance of all religions, and in 380 the Emperor Theodosius I issued the Edict of Thessalonica, making Christianity the official religion of the Empire.

While the rise of Christianity led to increased patronage of the arts, there is no 'Early Christian style'. Religious lessons were put into pictorial form to educate the largely illiterate faithful.

Images helped spread the Christian faith

The oldest Early Christian paintings are preserved on the walls and ceilings of catacombs, some so extensive as to be subterranean towns of passageways, sepulchers and funeral chapels cut into the rock. Popular Old Testament subjects portrayed were Noah's Ark, Daniel in the Lions' Den and Jonah and the Whale – all on the theme of salvation. Popular New Testament subjects came from the life of Jesus, such as Jesus the Good Shepherd (opposite), and especially his miracles, including the Healing of the Paralytic and the Resurrection of Lazarus.

In church architecture, Old St Peter's in Rome (below) exemplifies the Early Christian basilica. Built by Constantine over the tomb of St Peter, this church was taken down by Pope Julius II c.1505 to make way for today's St Peter's (page 94).

A visitor entered through the **atrium**, a rectangular forecourt, open to the sky, surrounded by columnar arcades. The **narthex** – an entrance hall or vestibule – gave access to the actual church, which consisted of the **nave** – a large rectangular space flanked by

Anonymous artist
Drawing of Old
St Peter's, Rome,
built c.333 CE
(destroyed)

**The Early Christian
basilica provided the
prototype for many
churches built on a
Latin cross plan with
a longitudinal axis.**

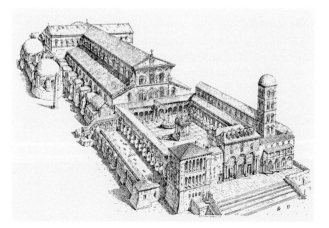

aisles – and the **transept**, perpendicular to the nave, giving the plan the shape of the letter T. The altar was in front of the semi-circular **apse** at the end of the church. Light came from the clerestory windows in the nave, made possible structurally by a lightweight wood ceiling.

In addition to the Latin cross basilica plan, early Christians also constructed **central plan** round or polygonal buildings such as Santa Costanza in Rome, originally built c.350 CE as the mausoleum for Constantine's daughter Constantia. Although the exterior is unadorned brick, the interior is richly embellished. Unlike the Latin cross plan with its wood ceiling and the many columns of the aisle arcades interrupting the space, Santa Costanza is topped by a dome that provides a large uninterrupted space, here surrounded by an **ambulatory** covered by a barrel vault encrusted with mosaics.

BYZANTINE ART

Constantine moved the capital of the Roman Empire to Byzantium in 330 CE, renaming it Constantinople. In 395, Theodosius I divided the Empire into two administrative regions: the east controlled from Constantinople and the west from Rome.

While the western Empire disintegrated, the eastern, Byzantine, portion of the Empire survived and thrived for centuries. At one of its several high points, under the Emperor Justinian (r.527–65), Byzantium held sway over the Adriatic Sea, much of Italy, including Ravenna, Rome and Sicily, as well as parts of the western Mediterranean coast in Europe and north Africa. Among Justinian's accomplishments was his codification of the laws, which influenced the development of law throughout Europe. With his wife, the Empress Theodora, his generous patronage of the arts resulted in the First Golden Age of Byzantine art. Justinian was, reputedly, the last of the Byzantine emperors to speak Latin as his first language. Greek had become the language of the Eastern Church, of everyday life and of trading between parts of the Empire.

Like the circular Santa Costanza, the octagonal Byzantine church of San Vitale in Ravenna, on the east coast of Italy, built 526–47, has a central plan. An advantage of these domed buildings is the large enclosed unbroken space, but a disadvantage is that the dome draws the visitor's eye upward, competing for attention with the altar. In contrast, the longitudinal axis of the basilican plan automatically focuses attention on the altar. Although San Vitale has windows on all three levels, light only enters the nave directly through the clerestory on the uppermost level, where it

is at its brightest, spotlighting the colourful interior: an opulent environment of sparkling glass, gold mosaics and polished marble slabs.

San Vitale contains a pair of mosaics, dated c.547, of Justinian (below) and Theodora, each with attendants, gathered around the altar. The ancient Roman interest in creating an illusion of three-dimensional figures and pictorial space was not perpetuated in Byzantine art. Nor was there a concern for naturalistic identifiable portraiture (pages 38 and 39); these Byzantine figures are only slightly individualized, all have nearly identical facial features and their clothing offers few hints about the bodies beneath. Ethereal and immaterial, they seem to hover – which is fortunate because they would otherwise step on each other's feet.

Byzantine mosaicists
Justinian and Attendants,
San Vitale, Ravenna,
c.547
Mosaic

Art serves to display political power and to present Justinian (and Theodora) to the public as perpetually pious.

Hagia Sophia, the 'Church of the Holy Wisdom', constructed 532–7 (overleaf), was also built for Justinian and Theodora. Designed by Anthemius of Tralles and Isidorus of Miletus, it ingeniously combines the advantage of the central plan (open space) with that of the basilican plan (single focal point). Structurally, Hagia Sophia's huge central dome is buttressed on opposite sides by two half domes of the same diameter as the central dome, which are in turn each buttressed by two smaller half domes. This practical

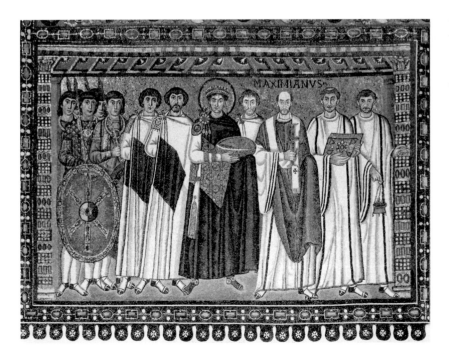

**Anthemius of Tralles and
Isidorus of Miletus**
Hagia Sophia, Istanbul,
interior,
532–7

**Just as San Vitale in
Ravenna displayed
Justinian's Byzantine
power and wealth in
the west, Hagia Sophia
in Istanbul did the
same in the east. The
building was converted
to a mosque after the
fall of Constantinople in
1453 and has changed
designation several times
since then.**

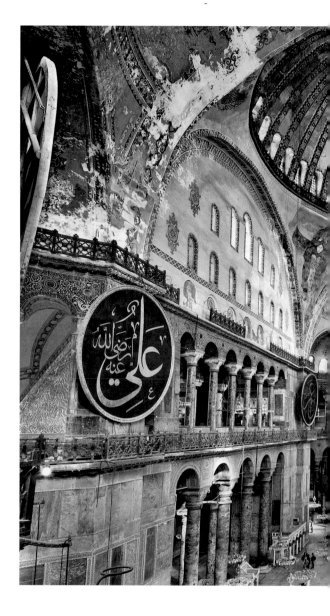

solution to the problem of resisting the lateral thrust of the central
dome creates a structurally sound and visually striking building,
the composition unified by the repetition of curving shapes.

Unlike the massive concrete dome of the Pantheon (page 42)
resting on a circular base, at Hagia Sophia a square base formed by
four sturdy piers supports the lightweight tile dome. The transition

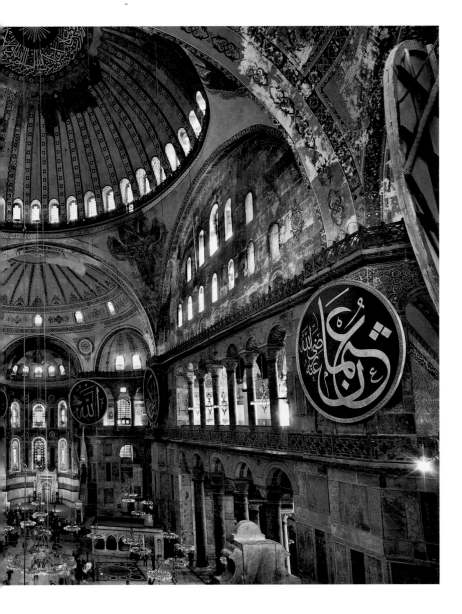

from the square base to the circular dome is achieved by four **pendentives** – curved triangular segments of a spherical surface – of masonry (two are visible above). Hagia Sophia is among their first appearances.

Another of Justinian's accomplishments was the founding of St Catherine's Monastery at Mount Sinai, Egypt, built 548–65, which

houses one of the world's largest collections of important early manuscripts. The Byzantines preserved many of the works of the ancient Greek authors for the future, when they would have a major impact on European thought. In addition, the monastery contains paintings and mosaics. The **icon** *Enthroned Madonna and Child with Saints and Angels* (opposite), painted in the late 6th century, is the earliest known example of this subject. Mary sits with the infant Jesus on her lap while the dragon-slaying saints Theodore of Amasea and George flank her, left and right respectively, each carrying a cross symbolically foreshadowing Jesus's crucifixion.

Beginning in 726, the Iconoclastic Controversy involved efforts to ban religious icons, ending the First Golden Age of Byzantine art. However, the **iconophiles** – those who favoured artistic depictions of saints – overcame the **iconoclasts** in 843, initiating a Second Golden Age. The eastern Greek Byzantium-based version of Christianity diverged from its Latin Rome-based counterpart on various issues: linguistic, religious and political (especially the extent of the pope's power over the Eastern Greek Church). The final break occurred in 1054 with the Great Schism, in which the Eastern Orthodox and Roman Catholic churches excommunicated one another.

The Second Golden Age is represented by St Mark's Cathedral in Venice, begun in 1063. St Mark's is built on a **Greek cross** plan with four arms of equal length, as opposed to a **Latin cross** plan with one longer arm, like Old St Peter's (page 47). St Mark's has a dome in the centre and one over each arm.

A visitor entering St Mark's is enveloped in sparkling splendour. The sixteen windows in the base of each dome create atmosphere, but not a brightly lit space – the ideal setting for the glittering mosaics made with gold and glass **tesserae** (little cubes pressed into wet plaster) that decorate the walls and domes. The mosaics depict various religious figures and stories.

Surrounded by aggressive states, the territorial extent of the Byzantine Empire waxed and waned over the centuries. Loss of mastery of the seas to Venice, especially after 1204, and loss of much of Anatolia to the Ottoman Turks in the 13th and 14th centuries, impacted both agriculture and trade, and thus the economy and Byzantium's ability to defend itself. In 1453, Constantinople fell to the Ottoman Turks and the city became Muslim Istanbul.

Byzantine painter
Enthroned Madonna and Child with Saints and Angels, St Catherine's Monastery, Mount Sinai, Egypt, late 6th century
Encaustic on wood panel, 68.5 x 49.7 cm (27 x 19½ in.)

Many western images of Mary and Jesus would be based on Byzantine models such as this. This icon aided the faithful in prayer as they meditated on the image; although believed to embody the person depicted and to be capable of performing miracles, it was not to be worshipped as an idol.

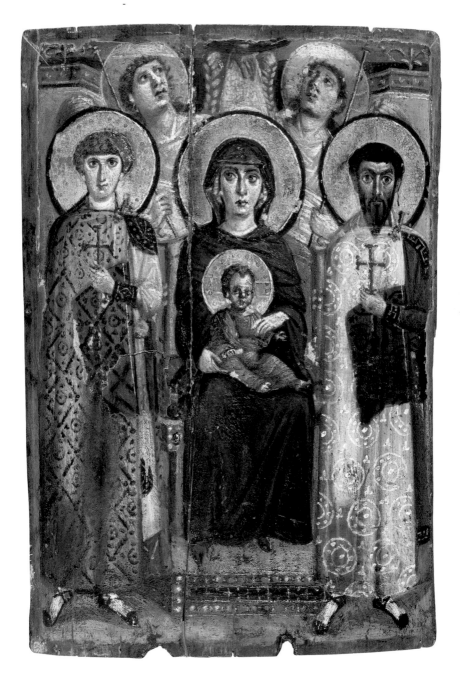

Early Medieval and Romanesque art
Is didactic imagery an effective tool for teaching?

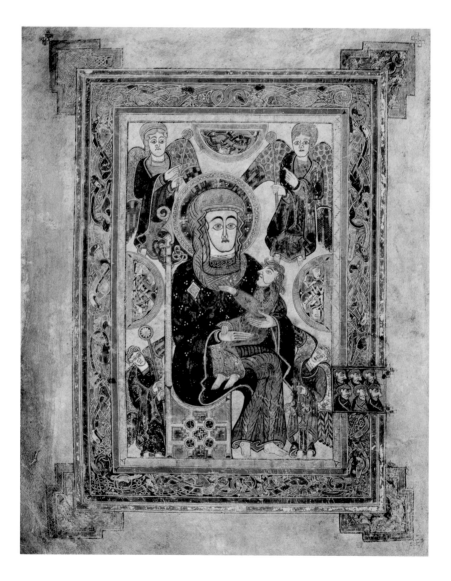

EARLY MIDDLE AGES (500–1000)

Western Europe was in political and social flux from the fall of
Rome in 476 until about 1000, as indicated by population statistics.
Around 500, the population in Roman-controlled regions is
estimated to have been c.22 million people, but by 650 that
number had fallen to c.14.5 million, rebounding to c.29 million
with the stability achieved under Charlemagne (r.768–814) and
his successors. A concomitant increase in the amount of cultivated
land and of trade occurred as the population grew, both of which
increased the wealth available to the nobility and Church for non-
agricultural investment. The Church provided a degree of structure
during the Early Middle Ages, and a variety of cultures and artistic
styles emerged and converged.

Irish illuminator
Madonna and Child,
from the *Book of Kells*,
c.800
Manuscript illumination,
33 x 24.1 cm (13 x 9½ in.)
Trinity College Library,
Dublin, MS A. I.

**This is the earliest known
representation of the
Madonna and Child
in western European
manuscript illumination.**

Migration period art (so-called Dark Ages)

The pressure of people migrating from Europe's north and east
towards the south and west into the territory of the Empire led
to an era termed the migration period or Dark Ages. By the
9th century the influx of various northern and eastern tribes
reshaped the population of Europe.

How inaccurate and misleading the term Dark Ages is for the art
of this era is demonstrated by the treasures of the ship burial, dated
625–33, discovered at Sutton Hoo in Suffolk, England. The trove
included luxury items such as a belt buckle, shoulder clasps and a
purse cover exquisitely decorated with gold, garnets and enamel. The
patterns are made in an **animal style**, characterized by unidentifiable
creatures stretched, twisted and interlaced with linear designs.

Animal interlace reappears in Irish and Anglo-Saxon
manuscripts – books hand-written on animal skin, the detailed
illustrations known as **illuminations**. Pagan motifs were assimilated
and adapted to Christian subjects in manuscripts produced by
monasteries in northern England and Ireland. No other paintings
remain intact from this period. The *Book of Kells* (opposite), created
by Irish monks, c.800, contains the Latin texts of the four Gospels.
The monks believed the beauty of the embellishment indicated the
importance of the text. The artist's technical skill, however, did not
include an interest in accurately representing the human body, for
Mary and Jesus are rendered as a decorative linear pattern. This
changing focus from the physical accuracy with which the ancient
Romans portrayed the human body to the spiritual abstraction
seen in the *Book of Kells* indicates the impact of a new source
of patronage for the arts in the increasing wealth and power of
the Church.

Carolingian art

Charlemagne (742–814) inherited the throne as King of the Franks (essentially today's France) in 768. Through almost constant warfare, he further expanded the Frankish territories to include Lombardy and pushed his northern boundary well into today's Germany. In 800, Pope Leo III anointed Charlemagne Emperor of the Romans.

Charlemagne encouraged study of the classics and classical art. His classical revival emphasized the importance of the human figure in art. For example, in the late 8th-century *Gospel Book of Charlemagne (Coronation Gospels)*, in the Kunsthistorisches Museum in Vienna, St John is shown with normal proportions and wears what appears to be a Roman toga. Charlemagne was a bibliophile and endowed monastic **scriptoria** where manuscripts were written. In fact, he raised the level of literacy and education to the extent that his reign has been called the Carolingian Renaissance.

The spread of Christianity throughout Europe was accompanied by the growth of monasticism. Daily life in a monastery generally followed the *Rule of St Benedict*, written in 516, which required prayer, work, discipline and obedience to the abbot. Charlemagne promoted Benedict's *Rule* throughout his realm. Although little actual architecture remains from the Carolingian era, a large plan for an ideal monastery, drawn on parchment c.820–30, survives. Because it is kept in the library of the abbey of St Gall (Stiftsbibliothek Sankt Gallen) in Reichenau, Switzerland, it is widely (and misleadingly) known as the *Plan of St Gall*. It gives a good idea of the basic components of a medieval monastery, which were the church, cloister, kitchens, crops, animals, infirmary, cemetery, servants' lodging and a school – monasteries were an important source of education during the Middle Ages.

Ottonian art

This period takes its name from the Ottonian dynasty established in the portion of the Carolingian Empire that is now Germany. The dynasty was founded by Otto I, crowned Holy Roman Emperor by Pope John XII in 962.

-

Large-scale sculptures were carved of stone and wood during the Middle Ages, but those of wood rarely survive

-

The *Gero Crucifix* (opposite) is thus a rarity, and among the oldest monumental medieval wood figures. Life-size at 1.88 m

Ottonian sculptor
Gero Crucifix,
c.965–70
Oak, paint and gold,
h. 1.88 m (6 ft 2 in.)
Cologne Cathedral

Other depictions of Christ crucified show him alive on the cross, wearing a king's crown, triumphant over death. The *Gero Crucifix*, in contrast, depicts Christ suffering in death. The corpus and cross are original; the gold embellishment behind is not.

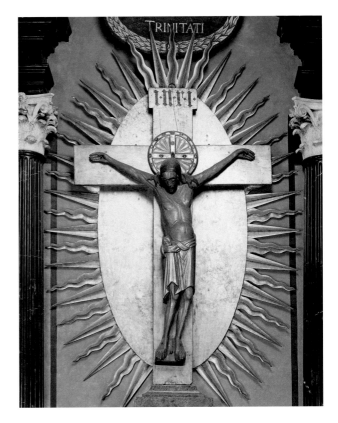

(6 ft 2 in.) high, dated c.965–70, it was donated by Archbishop Gero to Cologne Cathedral. In contrast to earlier depictions of this subject, this purposefully poignant sculpture is intended to convey profound emotion and to evoke the viewer's sympathy.

Ottonian manuscript illumination is represented by the *Gospel Book of Otto III*, dated late 10th century or c.1000 (Bayerische Staatsbibliothek, Munich). Comparable to the *Gero Crucifix*, in the *Gospel Book of Otto III* the gestures and poses of the painted figures are used to convey meaning and emotion – a medieval model for the nonverbal communication today known as 'body language'.

ROMANESQUE ART (1000 TO MID-12TH CENTURY)

The term Romanesque derives from an association with the Romance languages that developed from Latin. During this time, nation states began to solidify in France, Spain and England. Growing populations were organized by the feudal system in which

land owners permitted farming on their property in return for services. Contrary to popular expectations, the arrival of the year 1000 did not bring global disaster, and the post-millennial relief spawned religious fervour, pilgrimages, construction of churches and monasteries and flourishing activity in the arts.

The Romanesque thrived especially in France, and many Romanesque churches survive there, frequently as pilgrimage churches. **Pilgrimages** were a prominent aspect of medieval life; pilgrims travelled to worship **relics** (tangible mementoes of the saints and Christ).

-
Relics were believed to have miraculous power, often the ability to restore health
-

Popular destinations in western Europe included Santiago de Compostela (St James of Compostela) in Spain, Canterbury in England and Rome. While ostensibly the pilgrim's purpose was religious, the journey offered adventure, danger and a chance to exchange ideas with people from unfamiliar cultures.

Romanesque builders
Notre-Dame-la-Grande, Poitiers, façade, second quarter of 12th century

This Romanesque church façade is celebrated for its abundant sculpture, bundles of variously sized columns and range of patterns and textures.

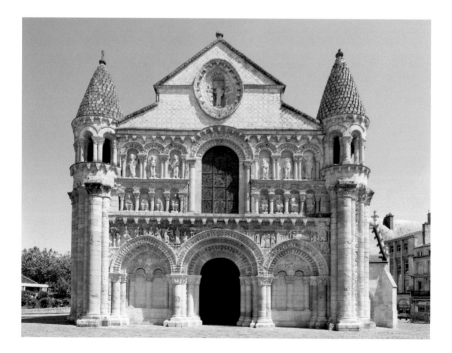

Romanesque builders
Sainte-Madeleine,
Vézelay, nave looking
towards altar,
1120–50

The visually harmonious
proportions in Vézelay's
nave result from the use
of simple mathematical
ratios to determine the
dimensions.

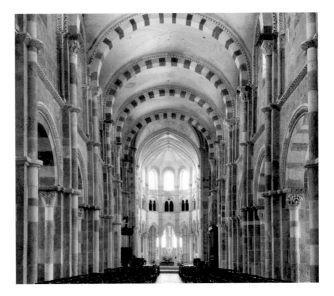

France

Many characteristics of Romanesque architecture are seen at
the little pilgrimage church of Notre-Dame-la-Grande in Poitiers
(opposite): semi-circular arches, thick stone walls, small windows
and proportions that are low and wide, with an emphasis on
horizontal lines. The façade arches contain figures of the twelve
apostles and two bishops, and various biblical scenes are carved
in high relief. Originally the sculpture was colourfully painted,
enriching the effect and making it easier to see the figures.

Romanesque church builders used several types of vaulting. The
barrel (tunnel) vault, as at Notre-Dame-la-Grande in Poitiers and
Santiago de Compostela (page 63), was the most common. A stone
vault offers superb acoustics and minimizes the risk of fire that often
destroyed wood ceilings during the Middle Ages. However, because
a stone barrel vault is heavy and exerts a lateral thrust on the walls,
the nave windows may be eliminated to create a stronger structure,
resulting in a dark interior.

In contrast, the nave of the pilgrimage church of Sainte-
Madeleine in Vézelay (above), built 1120–50, is unusually light
for a Romanesque church. This is the result of building with **cross
(groin) vaults** – two barrel vaults intersecting at right angles – which
automatically leaves flat spaces on the upper walls for windows. The
voussoirs (wedge-shaped stones) of the arches, alternating black
and beige, create zebra-like patterns.

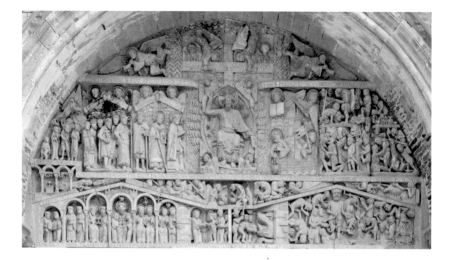

The fact that the Church was a major source of artistic patronage during the Middle Ages, combined with widespread illiteracy, encouraged the use of art as simultaneously decoration and a didactic teaching tool. By telling Bible stories and conveying moralizing messages, artists created the equivalent of picture books for those unable to read. Focal points for Romanesque architectural sculpture were **tympana** (singular: **tympanum**, the semi-circular area above a doorway), column capitals and gutter spouts in the form of gargoyles.

The tympanum of the pilgrimage church of Sainte-Foy in Conques (above), carved in the early 12th century, tells the story of the Last Judgement. The large central image of Christ within a **mandorla** (a pointed oval of light, the word derived from the Italian for almond) is characteristic of Romanesque tympana. The souls are weighed, one's fate shown literally to hang in the balance. At the right hand of Christ are the saved, while at his left are the damned, some being forced into the Mouth of Hell. At Conques, the lower right section depicts each of the Seven Deadly Sins receiving an appropriate punishment in Hell. For example, the poacher of the abbey's game is roasted on a spit by retaliatory rabbits. The graphic depictions of the punishments in Hell that await transgressors were meant to mould public behaviour; it was said that if the love of God did not deter people from sin, perhaps fear of Hell would.

Especially popular with Romanesque sculptors was the portrayal of the *Madonna and Child Enthroned* (opposite). This was reflected by the rise of the Cult of the Virgin Mary, evidenced by the many churches and cathedrals dedicated to Mary, or Notre Dame (Our

Romanesque sculptor
Last Judgement
tympanum, Sainte-Foy, Conques, France, early 12th century
Limestone and paint

This tympanum, like other Romanesque examples, conveys a message made memorable through visual preaching, using iconography familiar to the illiterate 12th-century audience.

Lady) in French. Unlike the painting of this subject in the *Book of Kells* (page 54), here mother and child sit stiffly, immobile, staring forwards instead of interacting; not the slightest hint of maternal warmth is even implied in this formal representation. The non-naturalistic proportions of the human figure is characteristic of Romanesque art. Drapery appears to be pleated, forming parallel ridges that end in perfect zig-zag hemlines, impossible for even the most skilful tailor to achieve in fabric. Abandoning the visible earthly world for the spiritual heavenly world, garments need not obey nature's laws of gravity, for the folds flow down on Mary's legs but up her arms.

Romanesque sculptor
Madonna and Child Enthroned, Notre-Dame d'Orcival (Auvergne), France,
12th century
Walnut, silver, silvered copper and polychrome, h. 70 cm (27½ in.)

Here Mary is shown as the Throne of Wisdom, from the Latin *sedes sapientiae*, in which Jesus, representing divine wisdom, sits. The family resemblance between mother and child, shown as a miniature man, is strong.

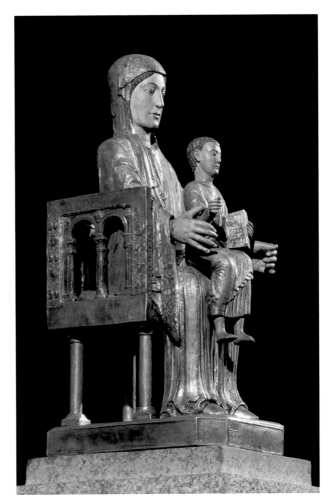

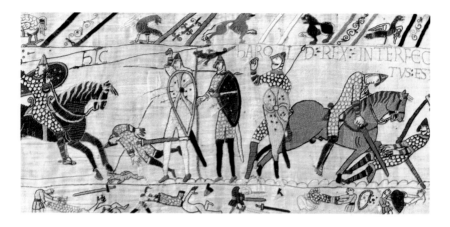

England

The Romanesque style, initially developed in France, spread
rapidly throughout Europe. England had a special link to the
French Romanesque because the English King Edward the
Confessor grew up in Normandy and imported masons to work
on the earliest Romanesque building in England – Westminster
Abbey in London.

When Edward died without issue in 1066, there was a strong case
for William, Duke of Normandy (c.1027–87), related by marriage
to the ruling family of England, to accede to the English throne.
The contest for the crown ended when William defeated Harold
Godwinson at the Battle of Hastings. William became the first
Norman king of England and was known thereafter as William the
Conqueror. This story is depicted on the *Bayeux Tapestry* (above),
begun shortly after 1066, in a simplified style, including only the
essentials. Chronicled are military strategies, weaponry, armour
and much more, including soldiers in combat, dining and travelling.

Although William perpetuated aspects of the Anglo-Saxon
traditions and laws, Norman French culture – which arrived in
England with him – would have an important impact in England.
Massive Durham Cathedral with its rib-vaulted nave shows the
influence of Norman Romanesque architecture.

Italy

A unique version of Romanesque architecture developed in Italy,
especially in Pisa. The cathedral (*duomo* in Italian), built 1063–92,
and the bell tower (*campanile* in Italian), begun 1173, better known
as the 'leaning tower of Pisa', are distinguished by multiple storeys
of arcades and surfaces inlaid with white and green marble.

Anonymous embroiderers
Death of Harold,
Bayeux Tapestry,
late 11th century
Wool embroidery on
linen, height c.49.5 cm
(19½ in.), total length
c.70.41 m (231 ft)
Centre Guillaume le
Conquérant, Bayeux

Although called a
tapestry, in which
the design is created
as the fabric is woven
on a loom, this would
more accurately be
named the *Bayeux*
***Embroidery*, as it is linen**
fabric embroidered with
coloured wool threads.
This section shows
the death of Harold
Godwinson.

The cathedral was designed by the master builder Buscheto and its façade by Rainaldo. The bell tower, designed by Bonanno Pisano, is a separate structure, like others in Italy, whereas the norm elsewhere in western Europe was two bell towers integral to the façade. Pisa's bell tower leans due to a faulty foundation.

Spain

As noted above, the goal for many pilgrims was the Cathedral of Santiago de Compostela in northwest Spain, presumed to be the burial place of the apostle St James the Great. Although the façade has been renovated in a later Baroque style, the vast nave, covered by a ribbed barrel vault, remains authentically Romanesque (below). Semi-circular ribs reinforce the vault, whose lateral thrust is buttressed by the flanking aisles and further resisted by the thickness of the walls. Windows in the outer walls are omitted because they would weaken the structure, which results in a rather dark interior. The motif of two small arches surrounded by a larger arch, found in the gallery, is common in Romanesque architecture and will be perpetuated for centuries.

Spanish builders
Cathedral of Santiago de Compostela, Spain, 1075–1211, nave looking towards altar

At the end of their arduous journey, Santiago de Compostela welcomed the pilgrims and was unlikely to disappoint.

Gothic art
Without the invention of the flying buttress and pointed arch, how different might Gothic architecture have been?

French illuminator
Detail of *St Roch*, from
a French *Book of Hours*,
third quarter of
15th century
Manuscript illumination,
overall size of folio
19 x 14 cm (7½ x 5½ in.)
Rauner Special
Collections Library,
Dartmouth College,
Hanover, New
Hampshire,
MS. Codex 003103

**Roch shows a bubos
(hence bubonic) or
plague abscess to an
angel. People did not yet
know that this bacterial
infection came from fleas
carried by rats.**

The term Gothic refers to the style of art and especially
architecture created in the mid-12th century in the Île-de-France
(the area around Paris). The style spread across western Europe,
remaining popular through the 15th century in France, with aspects
persisting later in Germany and England.

Economic growth through the mid-14th century increased
the disposable wealth available to the aristocracy, who prospered
as land owners by collecting rents and taxes. The population was
still primarily agricultural, but becoming increasingly urbanized.
Western Europe's population may have doubled between 1000 and
1340, however, famine throughout the 14th century and repeated
outbreaks of the bubonic plague, known as the Black Death,
during the 1340s, and at its most devastating 1347–51, drastically
reduced the population by as much as a third. The plague had major
economic and spiritual impacts.

Believing the plague was sent by God as a punishment for sin,
many people turned to their faith in the hope of being spared.
Artists depicted horrifying images of the disease and burial of
the dead. Some people sought to assuage God's wrath by acts of
extreme penitence. Flagellants paraded in front of large crowds,
whipping themselves bloody – which would have done more to
spread the disease than to abate it.

St Roch (opposite) is the patron saint of plague victims. Born
c.1348 in Montpellier, the pious son of a French nobleman, he was
said to have contracted the plague while miraculously curing the sick
during an epidemic. In this French Gothic manuscript illumination,
a characteristic raised blackened sore on Roch's leg is depicted.
The dog that brought him bread and licked his skin lesions during
his illness accompanies him.

FRANCE

Although late medieval architecture was largely in the service of
the Church, wealthy people constructed defensive castles for
themselves, their family and the court. Behind St Roch is a medieval
French castle – powerful, with thick stone walls and crenellated
towers with **machicolations**, which would have been approached
over a drawbridge and surrounded by a dry or wet moat.

What is called 'Gothic art' today was initially called the 'French
style'. The Italians, preferring the classical style, regarded the Gothic
style as barbaric, and as the best known of the barbarian tribes were
the Goths, they derided the style by calling it Gothic. In contrast to
Romanesque churches' solidity, massiveness, thick walls, round-

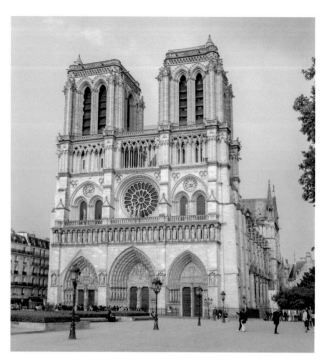

French builders
Cathedral of Notre-
Dame, Paris, west façade,
1163–c.1250, mostly first
half of 13th century

**Fire, feared throughout
the Middle Ages, did
devastating damage
to Notre-Dame on
15 April 2019. The
cause of the fire, which
destroyed the roofs and
spire, is still debated.**

arched windows and horizontal emphasis, Gothic churches stress the
vertical and appear delicate, the walls largely eliminated by building
with pointed arches and flying buttresses.

Key to the beginning of Gothic architecture was Abbot Suger
(1081–1151), a Benedictine monk, advisor to the kings of France,
and regent of France during the Second Crusade. Suger sought to
glorify God, the king and himself through the reconstruction of the
abbey church of Saint-Denis just north of Paris. Beginning c.1140,
Suger worked on the façade, narthex and east end. Foregoing
humble anonymity, he included his image in stained glass and
sculpture and his name in inscriptions. Gothic churches would use
the façade of Saint-Denis as their model for the three portals, two
towers (planned) and one circular **rose (wheel) window**.

Construction of the Early Gothic Cathedral of Notre-Dame-de-
Paris (above) began in 1163 at the apse end, as was customary. With
only rare exceptions, Christian churches are built with the apse
and altar on the east and the entrance on the west. Notre-Dame's
Early Gothic façade retains large areas of solid wall – a Romanesque
remnant. Here in the Early Gothic, horizontals and verticals receive
equal emphasis.

As the Gothic develops, the verticals are increasingly accentuated

Notre-Dame's significant height required the addition of stabilizing flying buttresses in the 1180s. Although the cathedral was completed in 1235, medieval modernization quickly began, which included enlarging most of the clerestory windows (making the four-storey nave elevation into three stories) and doubling the flying buttresses.

The second phase of Gothic, the High Gothic, began with Notre-Dame Cathedral in Chartres, built, as was customary, on the highest elevation in the city. Soaring heavenward, this was the first cathedral designed with flying buttresses integral to its structure. The potential of this dynamic system is seen in the nave (below)

French builders
Cathedral of Notre-Dame, Chartres, nave looking towards altar, vault finished by 1220

In the High Gothic, the nave elevation is typically three storeys: the arcade with pointed Gothic arches, the triforium (gallery) and the clerestory.

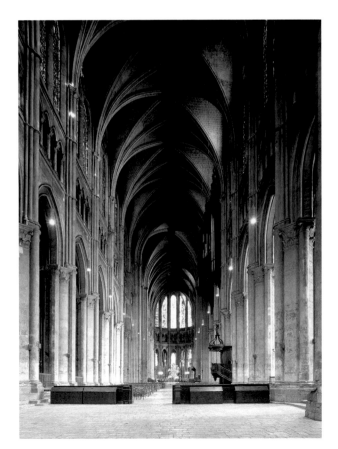

where all shapes are tall and slender. The exterior flying buttresses make it possible to largely eliminate the wall in between them, accommodating huge windows. This does not create a brightly lit interior because stained glass blocks much of the sunlight from entering, but it dapples the interior with flecks of coloured light that change constantly as the sun moves. The Gothic windows depict the religious stories that had been told in Romanesque murals.

Rayonnant Gothic, the third phase of Gothic architecture, appeared by the mid-13th century. The term derives from *rayonner*, French for 'to shine' or 'to radiate'. The style centred on Paris under King Louis IX (r.1226–70), who brought stability and peace to France.

An excellent example of Rayonnant Gothic is the Sainte-Chapelle (Holy Chapel) in Paris. Consisting of an upper and a lower chapel, the little building was, in effect, an enlarged reliquary built to contain relics Louis IX acquired. The walls of the upper chapel are mostly stained glass which, on a sunny day, surrounds the visitor with multi-coloured sparkling light (opposite).

The Kings Window shows the King of France with the biblical kings David and Solomon, thereby linking Louis IX's ancestry to the Old Testament and adding legitimacy to his political ambitions. Louis IX is shown buying relics of Christ, including the Crown of Thorns. By associating Christ's Crown of Thorns with Louis IX's crown, Louis is presented as God's royal representative. Art and politics have long been allies.

Equally colourful but in a different medium and on a different scale, manuscript illumination achieved a high point during the Gothic era. The finest quality manuscripts were produced in Paris; in addition to those of the usual sizes, extremely tiny books such as the *Book of Hours* (a private prayer book) of Jeanne d'Évreux, Queen of France, illuminated c.1324–8 by Jean Pucelle, which measures only 9.9 x 7.2 x 3.8 cm (3⅞ x 2⅞ x 1½ in.) with the binding (Cloisters Collection, Metropolitan Museum of Art, New York), display extraordinary technical wizardry and manual dexterity. Manuscript illumination was influenced by stained glass: thus reds and blues dominate in both; manuscript figures have black outlines comparable to the lead cames surrounding each piece of glass; and both mediums favour ornamental, two-dimensional imagery.

The fourth and final phase of Gothic architecture, the Flamboyant Gothic, is represented by the small parish church of Saint-Maclou in Rouen, designed in 1434 by Pierre Robin, except the west façade, which is perhaps by Ambroise Havel, 1500–21. Saint-Maclou is thoroughly decorated with the undulating flame-

French stained glass artist
Detail of Kings Window, Sainte-Chapelle, Paris, upper chapel, 1242–8, stained glass

This window portrays many scenes of coronations (twenty-one in total), further associating the biblical kings with the kings of France.

like curves of stone tracery that give this style its name. The architectural structure is not innovative, but the way in which it is decorated is: using a mallet and chisel to give stone the appearance of delicate lace.

Stone was also carved into figurative subjects such as the *Madonna and Child*. Frequently depicted during the Romanesque era (page 61), the image maintained its popularity throughout the Gothic era. The example known as *Notre-Dame-de-Paris* (overleaf), carved of marble in the early 14th century, still stands in the cathedral of that name. Unlike the Romanesque examples, the

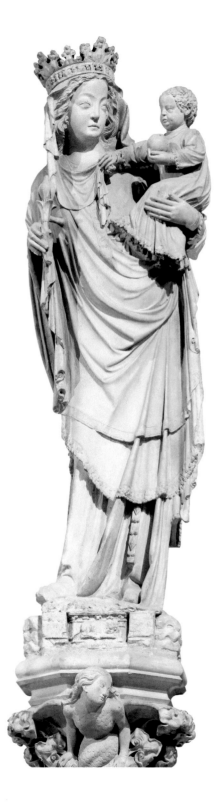

French sculptor
Notre-Dame-de-Paris,
Cathedral of Notre-
Dame, Paris,
early 14th century
Marble, h. 1.8 m
(5 ft 10 in.)

**Graceful and relaxed,
wearing layers of clothing
and a large crown,
Mary is portrayed as
a fashionable French
princess.**

Gothic mother and child now interact, both have naturalistic body proportions and they wear garments with soft flowing folds. Mary stands in what is descriptively called the **hip-shot pose**, supporting her child on her projecting hip.

GERMANY

The Pope confirmed the German Frederick I (Barbarossa) (1122–90) emperor of the Holy Roman Empire in 1155, and Frederick remained so until his death. Yet Frederick had many conflicts with the Pope, as did the other European monarchs, over the control of bishops' appointments and of Church property in his realm. Although the Holy Roman Empire included Italy as far south as Rome, Frederick invaded Italy five times to reinforce his authority, bringing Italian ideas and perspectives back to Germany with him.

While emphasis on emotion is a characteristic of Gothic art, the emotion is not always pleasant. Contemporary with the French *Notre-Dame-de-Paris* (opposite), but in striking contrast to it, is the German *Röttgen Pietà* (below), c.1300–25. It is

German sculptor
Röttgen Pietà, Germany, c.1300–25
Wood and polychrome, h. 87.63 cm (34½ in.)
Rheinisches Landesmuseum, Bonn

Among medieval depictions of this subject, the *Röttgen Pietà* is especially gruesome. Christ's body is emaciated, his gaping wounds gush blood and his head drops listlessly back, wearing a crown of thorns.

intentionally poignant, even unnerving, meant to make the viewer
feel pity – hence the word **pietà**. Sculptures of this subject were a
medieval German speciality. The image was to be contemplated at
vespers (evening prayers) and the faithful were to grieve with Mary
over her dead son. Magnification of their raw suffering encouraged
empathy and sympathy.

ENGLAND

In England, the French Gothic style of architecture was adapted
and modified to become uniquely English. Early English Gothic,
relatively restrained and unemotional, is represented by Salisbury
Cathedral, largely designed by Nicholas of Ely and built 1220–70.
Salisbury spreads out on a broad lawn, with low, wide proportions
having little need for flying buttresses, and a square east end.
In contrast, French Gothic cathedrals were built in the centre
of the city, with comparatively compact plans, high and narrow
proportions dependent on flying buttresses, and a rounded east end.
Comparison of Salisbury's façade with that of Amiens Cathedral,
started the same year, makes the differences evident.

-

**English Gothic architecture gradually became more extreme,
as if testing the limits of Gothic form**

-

The result is found in the Late Gothic Chapel of Henry VII
(opposite), in Westminster Abbey, London, designed by Robert
and William Vertue, built 1503–19. The ceiling is constructed using
fan vaulting, a descriptive term meaning that the radiating ribs
resemble an open fan. Here, however, the brothers extended the
ribs to form **pendant vaults** with hanging central bosses. Distinctly
English, this is the ultimate exaggeration of what started as simple
ribbed vaults.

ITALY

With wealth from banking and trade, Italy's individual city-states
asserted their independence from the Holy Roman Empire, vying
with one another militarily and in displays of civic wealth through
their art and architecture. Although the Gothic quickly became
popular throughout the rest of Europe, Italy was the exception,
instead renewing interest in its antique past.

**Robert and William
Vertue**
Interior, Chapel of
Henry VII, Westminster
Abbey, London,
1503–19

**The usual solid surface of
a ceiling dissolves into a
web of stone tracery, the
bosses descending into
the space of the chapel.**

.

It may be said that the artist Giotto di Bondone of Florence (c.1267–1337) redirected the development of Western painting. Compared with paintings created earlier during the Middle Ages, especially those in the Byzantine style, Giotto's works display a new interest in observing the real world. The author Giorgio Vasari (1511–74) began his book *Le Vite de' piu eccellenti pittori, scultori, e architettori* (*Lives of the Most Excellent Painters, Sculptors, and Architects*), first published in 1550, with art of the late 13th century and continued through to his own lifetime, focusing on Italian, especially Florentine, art. Vasari wrote about Giotto's innate interest in nature, saying that when Giotto was only ten years old, the Florentine artist Cimabue saw him 'drawing a sheep from nature' on a stone and was so impressed that he took Giotto as his pupil.

Giotto is best known for the frescoes he painted in the Arena (Scrovegni) Chapel in Padua, 1305–6, portraying the story of Mary and Jesus Christ. In the *Lamentation (Mourning of Christ)* (above), the hill leads the viewer's eyes to the heads of Mary and Christ,

Giotto
Lamentation (Mourning of Christ), Arena (Scrovegni) Chapel, Padua, 1305–6
Fresco, 200 x 185 cm (78¾ x 72⅞ in.)

Giotto introduced a new style of narrative clarity by simplifying his figures and cleverly using the composition to enhance the subject depicted.

placed low and off-centre. This deviation from the norm – we
are used to finding the centre of attention in the centre of the
composition – increases the tension. The figures form a circle
around the heads of mother and son but leave a space for one more
person, thereby inviting the viewer to join the mourners. Three-
dimensional figures exist within adequate pictorial space, all action
taking place on a shallow stage that keeps the figures very close to
the viewer, adding to the impact of powerful human emotions.

KEY IDEAS

Early Christian and Byzantine: Christianity has a major impact
 on art through patronage and didactic imagery.
Early Medieval: Various separate cultures and styles in art include
 Migration ('Dark Ages'), Carolingian and Ottonian.
Romanesque: Religious fervour and pilgrimages lead to new
 architectural developments. Churches feature stone-vaulted
 naves, thick walls, round arches, small windows and dark
 interiors. Sculpture tells Christian moralizing stories.
Gothic: Cathedrals reach great heights due to pointed arches
 and flying buttresses, making thin walls with huge windows
 possible. Stained glass and manuscript illumination reach
 their peak.

RENAISSANCE THROUGH NEOCLASSICAL ART

-

The Renaissance revival of culture after the
Middle Ages leads to a series of styles as
the pendulum of taste swings between
the intellectual and the emotional

-

Renaissance and Mannerist art
To what extent was the art of the Renaissance based on that of ancient Greece and Rome?

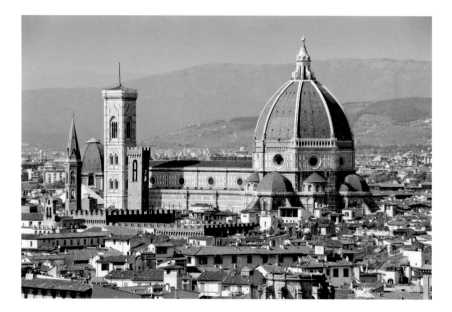

RENAISSANCE

The term Renaissance derives from the French word *renaissance* meaning 'rebirth', because culture in western Europe as a whole was renewed, taking inspiration from the ancient Greeks and, especially, the ancient Romans.

Early Renaissance
Italy
The culture of western Europe benefitted from the conquest of Constantinople by the Ottoman Turks in 1453 because the Byzantine intellectuals who fled the city for Italy energized the development of humanism. Based on the study of classical antiquity, particularly the writings of ancient philosophers such as Plato, humanism emphasized experience through the body, emotion

Filippo Brunelleschi et al.
Cathedral, Florence, dome,
1420–36
Dome w. 42.2 m (138 ft 5 in.), h. 114.6 m (376 ft)

A major landmark, visible throughout the city, Florence's *duomo* has the largest dome built since the Roman Pantheon.

and the environment. Although interest in classical cultures had existed in Italy previously, the refugees brought both their own interpretations and actual manuscripts that preserved the culture of ancient Greece and Rome in its original form. This reinforced the shift in focus from the sacred to the secular, from the importance of heaven to that of earth, from God-centred to human-centred thought, and from reliance on religious faith to belief in reason and science.

Florence, Siena and Milan developed into banking powerhouses, providing loans and financial services to merchants, royalty across Europe and the papacy. Venice, Genoa, Siena and Pisa dominated trade between the Mediterranean basin and northern Europe. Although competition, and even armed conflict, among these major powers did not end, their interactions moved into more diplomatic, economic and cultural spheres. Resources previously earmarked for military conquest could now be used by the cities vying for cultural primacy; wealth was not left idle in Renaissance Italy.

The 15th-century Renaissance in Italy focused on Florence, spurred by the wealth and taste of the Medici family, generous patrons of the arts. Money generated by their wool workshops was used to found a bank and their wealth was multiplied by establishing branch banks in various cities in Italy. They made lucrative financial arrangements with the papacy as well. Art played a role in managing Florence's wealth: Masaccio's painting *The Tribute Money*, dated 1425, in the Brancacci Chapel of Santa Maria del Carmine, depicts Jesus's disciple Peter taking money from the mouth of a fish to pay the tax collector. The secular message is clear: Florentines must pay their taxes!

A characteristic of the Early Renaissance was a new interest in the individual

Emerging from medieval obscurity, artists were not only known by name but were personalities of interest in themselves.

One of the masterpieces of this era was the soaring dome of Florence Cathedral (opposite) by the architect Filippo Brunelleschi (1377–1446). When constructing the dome, stone was used at the base and brick, a lighter material, above; as at the ancient Roman Pantheon (page 42), the heavier material at the bottom self-buttresses the dome. However, Brunelleschi's innovative pointed dome exerts less lateral force than a hemispherical dome would and

also has a double shell, which is much lighter than the Pantheon's concrete dome. Eight major ribs, visible on the exterior, plus three minor ribs between every two major ribs, reinforce the octagonal structure.

Sculptors and painters of Early Renaissance Florence focused on the human figure and depicted the young and flawless as well as the elderly and imperfect

The range of anatomical types of interest to artists is demonstrated by Donatello (1386-1466) who sculpted the figure of David several times. The bronze version of 1430–40 in the Bargello National Museum, Florence, shows the shepherd boy with idealized anatomy. In contrast, Donatello's depiction of Mary Magdalene, 1453–5, in painted wood, now in the Museo dell' Opera del Duomo, Florence, shows that the physical effects of age and deprivation were also worthy of study and representation. The repentant sinner is portrayed as desiccated and emaciated after many years in the desert, demonstrating the power of imperfection to create an emotionally charged image.

In striking contrast is another Early Renaissance depiction by a Florentine artist of a standing nude woman garbed only in her long hair. Sandro Botticelli (1445–1510) favoured beauty in his painting of the *Birth of Venus* (opposite), 1485–6. While Donatello's Mary Magdalene comes from the Bible, Botticelli's Venus comes from ancient pagan mythology, reflecting the Renaissance interest in, and admiration for, Greek and Roman antiquity. This subject was made acceptable in Christian Florence by associating Venus with Jesus's mother Mary because both were sources of love. On the right, the Hora (Hour) of Spring runs to clothe Venus. On the left, wind gods blow Venus to shore, although which one owns which legs is unclear. Botticelli's anatomy is inaccurate (see Venus's boneless left arm and elongated left thigh), but his flowing lines are so beautiful that we may forgive these anomalies.

Northern Europe
Interest in reviving antique ideas was less evident in the north than in Italy, and patronage came more from individuals of an increasingly wealthy merchant class than from religious sources.

Philip the Good, Duke of Burgundy from 1419 to 1467, consolidated what is now Belgium, the Netherlands and part of

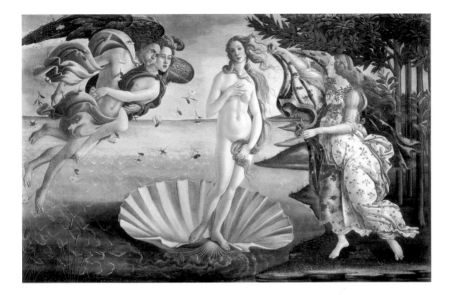

Sandro Botticelli
Birth of Venus,
1485–6
Tempera on canvas,
1.72 x 2.79 m
(5 ft 8 in. x 9 ft 2 in.)
Galleria degli Uffizi,
Florence

The nude figure, popular in antiquity but portrayed during the Middle Ages only when required by the subject (e.g. Adam and Eve), reappears often in Early Renaissance Italy.

northern France under his control. Philip created one of the most opulent courts in Europe, setting the style in luxury, with the wisdom and wealth to patronize the finest artists. Thriving commerce in Bruges, Ghent and other northern cities under his control produced a middle class with disposable income and an interest in art.

Among the artists patronized by Philip the Good was Jan van Eyck (c.1390–1441), born in Maaseyck (then called Eyck) in today's Belgium. Although Vasari was incorrect in referring to him in his *Lives* as the 'inventor of oil painting', Van Eyck was indeed inventive in developing and perfecting oil painting techniques. Growing out of the medieval manuscript miniature tradition, his paintings are so intricate that the viewer may want to use a magnifying glass. The image of Chancellor Rolin in Van Eyck's *Madonna of Chancellor Rolin* (overleaf) is detailed down to the stubble on his chin, and his rich attire reflects the thriving business in luxury textiles.

The *Madonna of Chancellor Rolin* is an example of a donor portrait, common during this period, intended to memorialize Rolin as both wealthy and devout. Mary is enveloped in abundant fabric with jewelled borders. The infant Jesus looks like a normal baby but behaves precociously as he blesses Rolin. The pictorial space is neatly divided into three sections: the foreground with the principal figures seated indoors, the floor tiles drawn in approximated linear perspective, concluded by the three arches; a middle ground with a

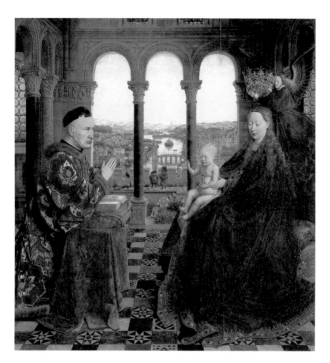

Jan van Eyck
Madonna of Chancellor
Rolin,
c.1435
Oil and tempera on wood,
66 x 62 cm (26 x 24⅜ in.)
Musée du Louvre, Paris

**In early 15th-century
northern Europe, painters
made an important
technical transition from
egg tempera to the mixed
technique, which would
lead to pure oil painting.**

garden and two men, limited by the crenellated wall over which they
look; and the background landscape with a curving river to lead the
viewer's eyes to the distant horizon, where depth is enhanced by
the use of **atmospheric (aerial) perspective**, recording the natural
phenomenon whereby the atmosphere diminishes the perceived
clarity of forms and colours in the distance.

Of particular note among Jan van Eyck's other paintings is the
Ghent Altarpiece, a huge **polyptych** (consisting of many panels)
painted with his brother Hubert, completed in 1432 and still in Saint
Bavo Cathedral, Ghent.

High Renaissance
Italy
In the later 15th century, artistic focus in Italy shifted to Rome,
due to the power and patronage of the popes, especially Julius II
(r.1503–13) and Leo X (r.1513–21). Here, Christianity and classicism
combined in the visual arts. The papacy, religious orders and wealthy
lay families competed to demonstrate their importance through the
visual arts, constructing and embellishing churches and chapels, civic
buildings and homes.

Nature rather than antiquity served as the inspiration for Leonardo da Vinci (1452–1519), born in Vinci near Florence. In his *Lives*, Vasari described Leonardo's physical beauty and charming personality, but also noted his unstable temperament. Today, Leonardo is known above all for his scientific approach to art. With an insatiable curiosity, he abandoned the medieval focus on heaven above and hell below in favour of the world in between.

His painting of the *Madonna and Child with Saint Anne* (below) depicts three generations. The lamb with which Jesus struggles is his symbol, for he is known as the *Agnus Dei* (Latin for the Lamb of God). This is very different from the Byzantine *Enthroned Madonna and Child* (page 53). Instead of being elevated on a

Leonardo da Vinci
*Madonna and Child with
Saint Anne,*
c.1503–19
Oil on wood, 168 x 112 cm
(66⅛ x 44 in.)
Musée du, Louvre, Paris

**The ability to arrange
several figures into a
compact composition
was considered a display
of skill in Leonardo's
time. Here his figures
fit within a triangular
outline, a device favoured
during the Renaissance
to give stability to the
composition.**

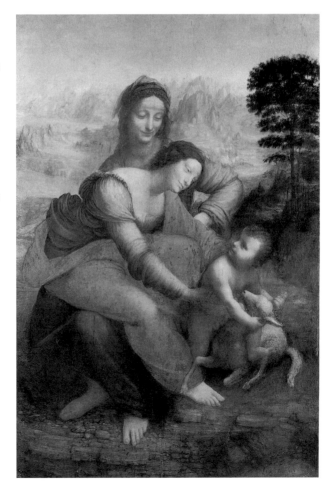

throne, here these religious figures are seated outdoors in a
scientifically rendered landscape. Pictorial depth is enhanced by
using atmospheric perspective. Leonardo modelled the shapes in
the **chiaroscuro** technique using light and shadow, and softened the
outlines with the **sfumato** technique.

A manifestation of the Renaissance interest in the individual was
the new focus on portraiture. Perhaps the most famous painting
in the world is Leonardo da Vinci's portrait of twenty-four-year-
old Lisa Gherardini, *Mona Lisa*, painted c.1503, in the Musée du
Louvre, Paris. Breaking from the earlier strict profile presentation in
portraits, Leonardo portrays his sitter in a three-quarter view. Her
shaved hairline and lack of eyebrows were fashionable. The painting's
renown derives from the sitter's ambiguous facial expression,
described as both happy and sad. Leonardo, incessantly inquisitive,
sought to document both her external and internal qualities.

The popularity of portraiture persisted in Italy in the later
16th and early 17th century, seen in the paintings by Sofonisba
Anguissola (c.1532–1625) and Lavinia Fontana (1552–1614).
Although active during the Mannerist and Baroque periods,
Anguissola worked in the Renaissance portraiture style. Known for
portraits of her family and self-portraits, she achieved international
fame, moving to Spain in 1559–60, where she joined the Spanish
court as a painter when only twenty-six years old.

While Leonardo da Vinci's approach to art was scientific, Raphael
(1483–1520), from Urbino, sought ideal beauty and perfection in
his figures and compositions. Pope Julius II invited Raphael to fresco
walls in the Apostolic Palace in Vatican City. In the Stanza della
Segnatura (Room of the Signature) the subjects, determined by
Julius II, relate to the four areas of learning: Theology, Philosophy,
the Arts and Law/Justice.

The *Disputation of the Holy Sacrament* of the Eucharist (opposite)
represents Theology, and demonstrates Raphael's predilection for
curving shapes, on both a large and small scale. He produced the
illusion of deep pictorial space using centralized, one-point, linear
perspective. Raphael made many preparatory studies; achieving
the appearance of effortlessness required a great amount of work.
The upper semi-circle is composed of Old and New Testament
figures, and the lower of saints and theologians of all eras discussing
the sacrament. Along the central axis is the Holy Trinity: God the
Father is at the top, with the Son and the Holy Spirit below; Mary
and John the Baptist flank Jesus.

While Raphael favoured the perfected beauty, calm and balance
of antiquity, Michelangelo (1475–1564), born near Florence,

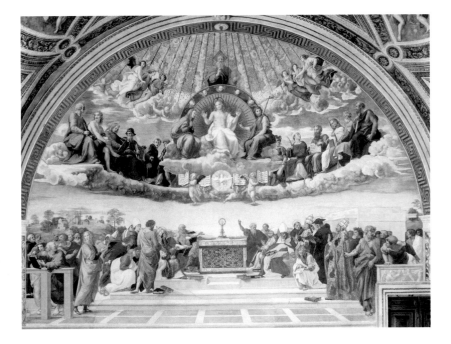

Raphael
Disputation of the Holy Sacrament,
1509–10
Fresco, 5 x 7.7 m
(16 ft 5 in. x 25 ft 3 in.)
Stanza della Segnatura,
Apostolic Palace,
Vatican City

This painting was considered the epitome of Renaissance style in Raphael's time.

created images of power, often through male figures, usually nude and impressively muscled, in both stone and paint.

Considering himself a sculptor rather than a painter, Michelangelo reluctantly frescoed the vast ceiling of the Sistine Chapel for Julius II, completed 1512. The complex design focuses on nine scenes from Genesis in the centre of the ceiling, the most famous being the *Creation of Adam.*

A major sculptural project that occupied (and angered) Michelangelo over many years was the tomb of Julius II, which was intended to have numerous sculpted figures. The Pope commissioned the tomb in 1505 but repeatedly interrupted Michelangelo's work and the tomb was never completed according to Michelangelo's design. Among the figures meant for the tomb was that of *Moses* (overleaf) carved 1513–15, holding the tablets of law. Michelangelo (like other artists) depicted Moses with horns, thought to be a mistranslation of the Hebrew word for 'rays of light' or 'shining', which could also be translated as 'horns'. Further, horns are a defining characteristic of the bull, an animal represented in the art of several cultures, including Assyrian and Minoan, for its strength. Michelangelo transforms the marble, enveloping Moses's legs in a generous sweep of drapery as his beard coils and cascades into his lap.

Michelangelo
Moses,
c.1513–15
Marble, 2.35 x 2.1 m
(7 ft 9 in. x 6 ft 11 in.)
San Pietro in Vincoli
(St Peter in Bonds),
Rome

***Moses* demonstrates
Michelangelo's ability to
convey a sense of barely
restrained tension, of
latent power waiting to
be unleashed.**

One of the dates suggested to mark the end of the High
Renaissance in Italy is 1520, the death of Raphael, the artist
considered most characteristic of the period's ideals. An alternative
is 1527, when conflict between the Holy Roman Emperor Charles V
(Habsburg, r.1519–56), on one side, and François I of France and
Pope Leo X on the other resulted in the troops of Charles V sacking
Rome. In spite of the brevity of the Italian High Renaissance, its
future impact was enormous.

Germany
Albrecht Dürer (1471–1528), born in Nuremberg, is the most
notable artist of the High Renaissance in northern Europe.
Multi-talented, he was a painter, printmaker, writer, theoretician
and publisher. He is known especially for his prints; multiple
copies reproduced inexpensively on paper spread his ideas. He

recorded his appearance throughout his life in many self-portraits; while other artists have also repeatedly been their own model (Rembrandt, Vincent van Gogh, Frida Kahlo), Dürer's self-portraits show a greater sense of what may be called self-appreciation, and he inserted his own likeness among figure groups in larger compositions.

He travelled to Italy in 1494 and again in 1505. Like Leonardo da Vinci, Dürer was intrigued by the natural world, examined it carefully and made many studies of various aspects of his environment. Northern Europe's political involvement in Italy formed a conduit, bringing many of the ideas of humanism to the north, and similar ideas are seen north and south of the Alps during the Renaissance.

Dürer's interest in amassing knowledge, especially about nature's oddities, is evidenced by a 1515 woodcut of a rhinoceros (below). This was not, however, made from life. An Indian rhinoceros had been given to King Emmanuel of Portugal as a gift, an unusual result of Portugal's exploration of new maritime trading routes to South Asia. Dürer received a sketch of the beast in a letter from a friend then living in Lisbon. The inscription describes the rhinoceros

Albrecht Dürer
Rhinoceros,
1515
Woodcut, sheet (trimmed
to image), 23.5 x 29.8 cm
(9¼ x 11¾ in.)
Metropolitan Museum
of Art, New York

**Dürer's prints were
widely distributed thanks
to the popularity of
the printing press and
movable type created by
the German Johannes
Gutenberg.**

as the colour of a freckled toad, covered with a hard thick shell and
the size of an elephant but with shorter legs.

In 1515 Dürer and Raphael exchanged works of art each had
created, additional evidence of artistic contact between the north
and Italy. In this year, Dürer attained the prestigious position of
court painter to Emperor Maximilian I, whose portrait he painted in
1519 (Kunsthistorisches Museum, Vienna). A successful artist could
now achieve fame and fortune. However, Dürer wrote about how
well he was treated in Italy, and how poorly in his own country.

Displeasure in much of northern Europe with the perceived
moral laxity of Rome, financial pressure and the sale of indulgences
led to the Protestant Reformation, which accelerated in 1517 in
Germany with Martin Luther. Reformation ideas spread rapidly.
As a result, northern artists gradually turned away from religious
subjects in favour of secular ones. Dürer became a follower of
Luther in 1519.

France

François I ascended the throne in 1515 at the age of twenty and
ruled until his death in 1547. His home, or, more accurately, one of

Domenico da Cortona (?)
Château of Chambord,
Loire Valley, France,
begun in 1519

**The largest of
all Renaissance
châteaux, Chambord
has 440 rooms and
365 chimneys, 14 big
staircases and 70 smaller
ones. The later Baroque
château of Versailles is
even larger.**

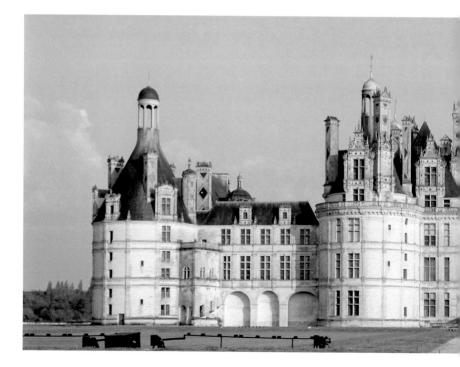

several homes built as public displays of power and wealth, was the Château of Chambord (below). France is celebrated for its castles; the most impressive of the Renaissance, including Chambord, are concentrated in the Loire Valley. Construction of Chambord started in 1519, perhaps designed by the Italian Domenico da Cortona (d.1549). François I had already demonstrated his admiration for Italian artists when he brought Leonardo da Vinci (and his paintings including the *Madonna and Child with Saint Anne*, page 83, and the *Mona Lisa*) to France in 1516, where the artist lived until his death in 1519.

The French château of Chambord features an extraordinary double spiral staircase that forms a cylinder, 9.14 m (30 ft) in diameter and 24.38 m (80 ft) high. Because the two staircases intertwine, a person on one can see, but not touch, a person on the other. This staircase leads up to the roof. French Renaissance châteaux typically have high slate roofs, but Chambord's roof is flat. Here a miniature town was constructed with tiny streets and buildings with turrets and chimneys, all embellished with inlay and sculpture.

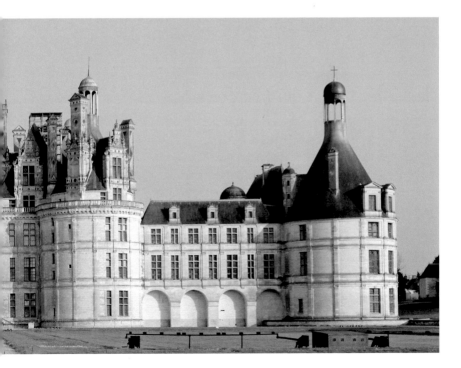

· ANNO · ETATIS · · SVE · XLIX ·

Hans Holbein the Younger
Henry VIII at 49,
1540
Oil on panel,
88.5 x 74.5 cm
(34⅞ x 29⅜ in.)
Galleria Nazionale d'Arte
Antica, Palazzo Barberini,
Rome

This historical document shows the English King to be huge, filling the surface with his lavish attire as he stares at the viewer. Holbein recorded every detail of the sitter's exterior; insight into his character was not required.

England

France's François I was a contemporary of England's Henry VIII, who came to the throne in 1509 at the age of seventeen. Both kings died in 1547. Home for Henry VIII (and five of his six wives) was Hampton Court Palace in southwest London. As at Chambord, defensive medieval features were retained for their picturesque appeal, but were no longer required due to increased political stability. Chambord is built of stone, but brick was used at Hampton Court, and windows were made larger: defensive architecture had been domesticated.

The appearance of Henry VIII (opposite) was carefully recorded by the portrait painter Hans Holbein the Younger (c.1497–1543), born in Germany but active in England. Holbein performed the same service for Henry VIII as Jan van Eyck had for Philip the Good, both painting portraits of potential brides for their employers. Holbein painted Jane Seymour, Henry VIII's third wife, and, after her death, Anne of Cleves became his fourth wife partly based on Holbein's portrait of her. However, the King did not like the flesh and blood version and divorced her.

Because of the Protestant Reformation, Holbein painted relatively few religious subjects. Like Dürer, he sided with Luther and the Reformation. This was a time of both political and religious turmoil. Henry VIII's support for the Reformation was less theological than biological: he wanted to divorce his first wife, Catherine of Aragon, because she had failed to give birth to a male heir. As a Catholic, divorce was not permitted. Henry's solution was to remove the Pope's power in England by creating the Church of England under his own control. The new Anglican Church granted the divorce, enabling him to marry Anne Boleyn in 1533.

The Roman Church responded to the Reformation with the Council of Trent (1545–63) which codified the Counter-Reformation and confirmed the use of didactic images in Church art in a reaction to the iconoclasm of several Protestant sects.

The Netherlands

While Holbein painted portraits of royalty, Pieter Bruegel the Elder (c.1525/30–69), born in the Netherlands, though active in Antwerp and Brussels, portrayed the peasantry. Bruegel's paintings, such as the *Peasant Dance* (overleaf), document aspects of the daily life of the peasant class. Such genre scenes were atypical for his time. It is believed that Bruegel was well educated and thus not from the social class he portrayed. Some of his subjects are based on Flemish proverbs, while others are caustic satires on life. These are not pure

fun, for Bruegel's paintings harbour deeper meaning, sometimes disguised in symbols. Bruegel mocked the Church, targeting avarice and the other Deadly Sins. He satirized human folly, stupidity, hypocrisy and those who are self-serving. In the *Peasant Dance*, a little picture of Jesus's mother Mary attached to a tree on the far right indicates that this is a religious celebration, but the church is in the distance whereas the tavern is much closer. Bruegel captures the lively animation of these people, encouraging our imagination to add the sounds and smells.

Pieter Bruegel the Elder
Peasant Dance,
1568
Oil on oak panel,
1.14 x 1.64 m
(3 ft 9 in. x 5 ft 4 in.)
Kunsthistorisches
Museum, Vienna

Although not of the peasant class himself, Bruegel is said to have dressed in peasant clothing to observe their way of life closely.

MANNERIST ART

A revival of classical ideals characterized the Renaissance in Italy and to a lesser extent in the north, but was followed by a rejection of those ideals. Consequently Mannerism (the term comes from the Italian for manner or style, *maniera*) is also called the anti-classical style. Renaissance artists typically favoured clarity of meaning, balance and harmony, anatomy based on antique ideals, three-dimensional pictorial space and primary colours. Mannerist artists, in contrast, tended towards complex compositions that obscure meaning, non-naturalistic anatomy presented in uncomfortable poses, ambiguous pictorial space and secondary colours.

The change in style corresponds historically with the upheaval that followed the 1527 sack of Rome by Charles V. Italian artists fled northwards, where French royalty welcomed Mannerism. The intended audience for the mid- and late 16th-century Mannerist style of art was not the general public but the aristocracy.

François I hired a team of Italian artists to decorate his château of Fontainebleau. Among them was Francesco Primaticcio (1504–70), from Bologna, who arrived in 1532 and would work in France for several decades. At Fontainebleau, Primaticcio created an original form of decoration, a refined style that reflected the sophisticated aristocratic tastes of the time. Primaticcio decorated the King's Staircase (below), combining painting and sculpture – media that previously would have been separated. The stucco figures receive far more attention than the little paintings they frame. In accord with Mannerist sensibilities, their proportions are distorted and their poses contorted. With decorative French elegance, the figures are charming and perfect, but barely our species. Their bodies are artificially attenuated, elongated, delicate, with small heads and big hips, yet they twist gracefully, unencumbered by clothing and unconcerned with conveying a profound or edifying message. Female nudes were a Fontainebleau specialty that accommodated the vogue for mannered eroticism – sinuous, sensuous, smiling and seductive.

Francesco Primaticcio
decorative figures,
upper wall of King's
Staircase, Château
of Fontainebleau,
Fontainebleau,
c.1541–5
Stucco

The importance of François I to the history of French art results largely from his appreciation and importation of Italian art and artists.

17th-century Baroque art

What was the impact of religion on art, and of art on religion, during the Baroque era?

The main artistic style of the 17th century was the Baroque, a term used to describe an imperfectly shaped pearl. Baroque art is characteristically dramatic, emotional and even theatrical. Patronage for the popular new style came from widespread sources. In Spain, Philip IV was a generous supporter. In France, Marie de' Medici and Louis XIV spent lavishly. In Italy, the Church's wealth provided funding for the arts.

Carlo Maderno
St Peter's Basilica, Rome, façade, 1607–15, h. 44.81 m (147 ft), w. 114 m (374 ft)

From the balcony, the focus of this visual display of the Church's power, the pope addressed the faithful in the large piazza before him.

ITALY

The Baroque style began in Italy when the papacy sought to make Rome the most beautiful city in Christendom for the Jubilee

of 1600. Rome was to regain its role as the centre of Western culture. Politically, the Habsburgs of Austria had nominal control of northern Italy, the Spanish throne controlled the south and the Papal States (including Rome) the central regions. The economy of northern and central Italy declined dramatically during the 17th century as English, Dutch and French products and services replaced those from the Italian states throughout Europe, north Africa and the Middle East. The papacy, however, remained sufficiently wealthy to undertake major building programmes to demonstrate its power and to bring the faithful a revised and refocused religious life. Each successive pope sponsored building campaigns – usually of palaces, churches and chapels – as well as the art to embellish them. Rome became a magnet for artists.

The Council of Trent (see page 91) provided the theological rationale for the popes' lavish spending on art and architecture that could counter Protestantism by putting religious teachings into paintings and other visual forms to instruct the common people. Images should be clear, to make them readily understood and memorable; realistic to make them easier to relate to; and emotional to engage the viewer and encourage piety. The Roman Church sought to reaffirm its doctrinal basis, improve the education of its clergy and turn away from the humanist focus of the Renaissance towards a more spiritual view of the world.

The major architectural monument of the Catholic Church is St Peter's Basilica in Rome. The building seen today (opposite) is unlike the Early Christian basilica that first occupied this location (page 47). The history of St Peter's is long and complicated but well documented. Old St Peter's was torn down by order of Pope Julius II in 1505, and the most important architects then worked on the design, including Bramante and Michelangelo. In 1602, to finish the structure and convert Michelangelo's Greek cross plan into a Latin cross plan, Pope Paul V appointed Carlo Maderno (1556–1629), from Ticino, as chief architect. The advantage of a Latin cross plan was more interior space for the many faithful – in fact, St Peter's is Europe's largest church.

Maderno used the **colossal order** to unify the vast façade which he treated much like a theatrical performance that builds from the wings to the balcony at centre stage. Thus, pilasters at the corners quickly double, then become columns, which then also double as they reach the middle section, which juts out still further towards the approaching visitor.

After Maderno's death in 1629, Pope Urban VIII appointed the architect and sculptor Gian Lorenzo Bernini (1598–1680),

from Naples, to replace him. The extreme drama and emotion that characterize Bernini's work (he also designed the piazza in front of St Peter's) are the essence of Baroque art. The calm composure characteristic of the art of Classical Greece and the Renaissance was contrary to the Baroque aesthetic. Instead, Bernini's *Pluto and Proserpina* (below), carved 1621–2, recalls the dramatic split-second action of Hellenistic sculpture. Bernini depicts Pluto (Greek Hades), god of the underworld, abducting Proserpina (Greek Persephone), goddess of spring. As he violently pulls her towards him, she pushes him away, struggling to free herself. By contrasting the physical actions of pulling and pushing, the sculptor made both appear more powerful. Bernini emphasized other effects through contrast: muscled Pluto differs from Proserpina's soft flesh. According to the myth, Proserpina is unsuccessful in her attempt to escape and will become, unwillingly, Pluto's wife.

The appeal of antique subjects, especially those involving sex, violence and nudity, persisted

Gian Lorenzo Bernini
Pluto and Proserpina,
1621–2
Carrara marble, h. 2.25 m
(7 ft 4 in.)
Galleria Borghese, Rome

Under Bernini's seemingly magic Baroque mallet and chisel, stone appears to come to life. Cardinal Scipione Borghese, rather than a secular patron, commissioned this pagan subject.

Caravaggio
Entombment of Christ,
c.1600–4
Oil on canvas, 3 x 2.03 m
(9 ft 10 in. x 6 ft 8 in.)
Pinacoteca Vaticana,
Vatican City, Rome

**Caravaggio did not
idealize the figures in
his religious paintings, a
decision that was not well
received by an audience
comfortable with a
division between the
sacred and the secular.**

One of the most influential Baroque painters was Caravaggio
(1573–1610), named after his town of origin near Milan. Perhaps
there is a connection between his bohemian lifestyle, violent
temper, lengthy police record and the heightened emotionality
of his paintings. In his *Entombment of Christ* (above), painted
c.1600–4, Caravaggio cleverly placed the viewer's eye level at the
slab of stone on which the figures stand, thereby implying that the
viewer is down below, in the grave, and is about to receive the body
of Christ. Caravaggio positioned the large figures very close to the
picture plane – in fact, some parts, such as the jutting elbow, appear
to project past the picture plane and out into our space. Enhancing
the drama is the painting technique of **tenebrism**, meaning a 'dark

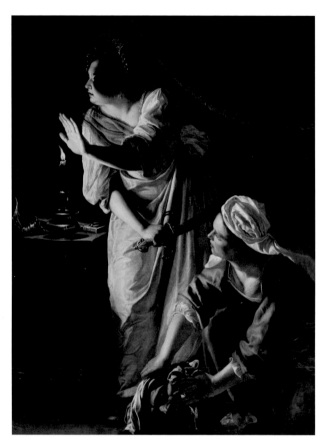

Artemisia Gentileschi
*Judith and Her
Maidservant with the
Head of Holofernes,*
c.1623–5
Oil on canvas,
1.87 x 1.42 m
(6 ft 2 in. x 4 ft 8 in.)
Detroit Institute of Art,
Michigan

**A single candle is the
only source of light
shown, yet Gentileschi
contrasts the brightest
highlights with the
darkest shadows, thereby
magnifying the horror of
the subject.**

manner', in which a bright spotlight focuses our eyes on the most
important parts of the painting, while dark shadows obscure all else.

The dramatic and theatrical aspects of the Baroque are especially
powerful in the paintings of Artemisia Gentileschi (1593–c.1653),
born in Rome, the daughter of the painter Orazio Gentileschi. A
prodigy, by the age of fifteen she was already an accomplished
painter. She was called one of the 'Caravaggisti', or a 'night painter',
because of her use of tenebrism.

A theme Gentileschi depicted several times is *Judith and Her
Maidservant with the Head of Holofernes* (above). Judith has enticed
the Assyrian leader Holofernes to drink himself to sleep. With the
help of her maidservant, she uses his sword to behead him, thereby
saving the Jewish people from the Assyrian King Nebuchadnezzar.
Gentileschi's religious paintings favour subjects such as *David and
Bathsheba*, *Susanna and the Elders*, *Salome with the Head of John the*

Fra Andrea Pozzo
*Triumph of St Ignatius
of Loyola,*
1691–4
Ceiling fresco
Sant' Ignazio, Rome

**The actual stone
architecture of the
church morphs
imperceptibly into
Pozzo's painted visual
trickery of endless
space. But if the viewer
steps away from the
intended viewing spot,
the distinction between
real and illusion becomes
evident.**

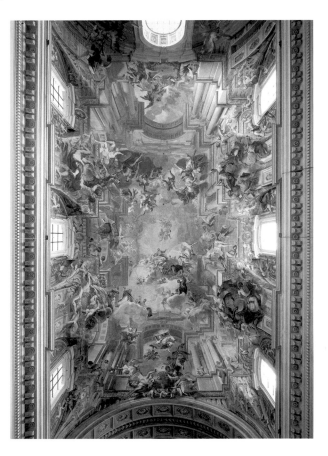

Baptist and *Jael and Sisera* – themes of betrayal, deception, abuse
and revenge. Her preference for such subjects, in which she was
sometimes her own model, may be connected with her rape and
betrayal by her teacher when she was seventeen.

A new kind of painting became popular in Baroque Italy:
illusionistic ceilings intended to trick the viewers' eyes. Among
the several examples in Rome, most notable is the fresco on the
nave vault of the church of Sant' Ignazio. Here Fra Andrea Pozzo
(1642–1709) painted the *Triumph of St Ignatius of Loyola* (above),
1691–4. The visitors' attention, however, may be drawn less to the
Saint and more to the extraordinary setting of open sky and fictive
architecture. Pozzo's skill has obliterated the ceiling using linear
perspective carefully calculated to be seen from a specific location
in the middle of the nave, conveniently indicated by the pattern in
the floor.

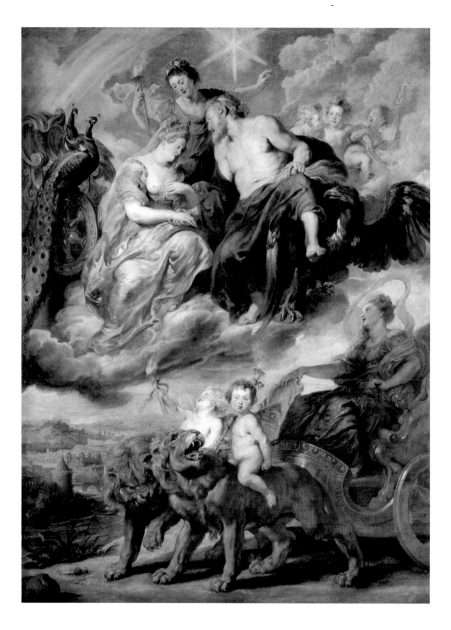

Peter Paul Rubens
*The Meeting of Marie
de' Medici and Henri IV
at Lyons,*
c.1621–5
Oil on canvas,
3.94 x 2.95 m
(12 ft 11 in. x 9 ft 8 in.)
Musée du Louvre, Paris

**Rubens made sensuality
and sumptuousness
visible in this allegorical
representation of an
historical event shown
to take place in the
company of Juno
and Jupiter.**

The Baroque style flourished widely outside Italy in art and architecture

FLANDERS

Although Baroque art originated in Italy, specifically in Rome, the style rapidly found favour throughout western Europe, adopted and adapted to local needs and aesthetics. The area known as Flanders includes Antwerp, Brussels, Ghent and Bruges – cities that were home to a successful merchant class. Wealthy and sophisticated, they fostered the arts. The painter most characteristic of the Baroque in Flanders was Peter Paul Rubens (1577–1640), German by birth but active in Antwerp. As was customary among young aspiring artists, Rubens studied in Italy, staying from 1600 to 1608. He developed a personal style that meshed northern with Italian aspects.

Rubens had many skills in addition to his talent as a painter, particularly in business and diplomacy. His studio in Antwerp employed many painters and took students, generating great wealth. Rubens received commissions from the royal courts of Europe, working for Italy's Duke of Mantua; Spain's Philip IV and his regents in the Netherlands, Albert and Isabella; England's Charles I; and France's Queen Marie de' Medici. The fact that Rubens was multi-lingual facilitated this international patronage.

In 1621, Marie de' Medici, widow of Henri IV of France, commissioned a cycle of twenty-four large oil paintings from Rubens intended for her Luxembourg Palace in Paris. The paintings were to immortalize her life as well as that of Henri IV, and to persuade people of the legitimacy of her right to rule France as regent after her husband's death even though she was not French. Rubens was the perfect choice for the task because he could dramatize even the most mundane event. For example, in one of the earlier scenes in the cycle, Marie de' Medici and Henri IV, already married by proxy, first meet in Lyons (opposite). It is unlikely that this event occurred in the heavens or that neither one was fully clothed!

Rubens's work displays the Baroque characteristics of dynamic diagonal movements and animated figures in unlimited spaces. He painted in terms of rich colour and light rather than line. His figures are characteristically full-bodied and fleshy, to the extent that the term 'Rubenesque' has entered our language to describe his favoured type of female physique.

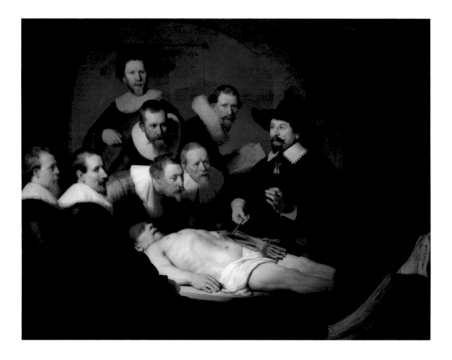

THE NETHERLANDS

After the end of Spanish rule in 1648, the Dutch Republic saw rapid economic growth as trade increased, manufacturing of woollens and other goods thrived and Amsterdam replaced Antwerp as the chief port of northern Europe. At this time, the Dutch Republic had the highest standard of living in Europe. A flourishing Dutch mercantile economy created a new source of patronage for the arts. Private individuals sought portraits and genre scenes to display in their homes. However, the Dutch wars with England in the 1660s led to a financial downturn and loss of its North American colonies (notably Nieuw Amsterdam became New York).

Rembrandt van Rijn (1606–69), born in Leiden, studied literature at its university before turning to painting. In accordance with the fashion of the time, Rembrandt painted many portraits. However, the group portrait was a new form, the challenge being to avoid a stiff row of heads. In the *Anatomy Lesson of Dr Nicolaes Tulp* (above), commissioned by the Amsterdam Guild of Surgeons, Rembrandt avoided a rigid composition by organizing the figures around the cadaver. The Baroque diagonal position of the body causes the feet to project outward, the effect mitigated by the book in the lower right corner. Here the dissected forearm is anatomically inaccurate.

Rembrandt van Rijn
Anatomy Lesson of Dr Nicolaes Tulp,
1632
Oil on canvas,
1.70 x 2.17 m
(5 ft 7 in. x 7 ft 1 in.)
Mauritshuis, The Hague

Drama takes precedence over naturalism in this Baroque painting, for no logical source of the light is indicated and the faces seem to be illuminated by light emanating from the corpse.

The death of Rembrandt's much-loved wife Saskia in 1642 coincides with the turning point in his life. In this year he painted the *Night Watch* (Rijksmuseum, Amsterdam), also a group portrait but on a huge scale and containing many more figures. Members of the Amsterdam civic guard are depicted as they go forth in the morning to welcome Marie de' Medici to their city.

The Dutch Baroque artist Rachel Ruysch (1664–1750), born in The Hague, specialized in flower paintings, then a popular subject in the Netherlands. The daughter of a botanist, she quickly perfected her skills, painting *Festoon of Flowers Hanging on a Nail* (below) in 1682 when only eighteen years old.

Still life paintings of flowers, food, small items and even insects were more than aesthetically appealing arrangements, for these items conveyed iconographic connotations. Wilting flowers and rotting fruit refer to the brevity of youthful beauty and of life. *Memento mori*, roughly translated from the Latin as 'remember you will die', and *Vanitas* or vanity subjects warned of death and the need to act properly in life. Specific flowers had

Rachel Ruysch
Festoon of Flowers Hanging on a Nail,
signed and dated 1682
Oil on canvas,
38 x 33 cm (15 x 13 in.)
National Gallery, Prague

The Dutch had great appreciation for flowers and prized Ruysch's paintings for their meticulously recorded, scientifically accurate details.

precise meanings: lilies represent purity and tulips nobility. There was an important market for tulips in the Netherlands during the 17th century.

SPAIN

The Habsburg King Philip IV of Spain (r.1621–65) appointed Diego Velázquez (1599–1660), born in Seville, as royal painter to his court in Madrid, where the latter painted many portraits of the royal family and members of the court. Velázquez recorded the actual appearance of his sitters. This interest in visual accuracy, and the skill to achieve it, had been honed in his earlier paintings of ordinary people from the lower and middle classes, such as *The Lunch*, c.1617 (opposite). Velázquez created a close-up view of men of three different ages conversing over a simple meal. The Baroque tenebristic light emphasizes the combination of contrasting textures, each almost tangibly real in appearance, down to the wrinkled table cloth.

Although in his capacity as royal painter Velázquez lived in Madrid, at his friend Rubens's suggestion and with the king's permission, in 1629 he travelled to Italy to study. There he gained an understanding of the Italian Baroque and took this useful souvenir home with him to Spain, as reflected in later works such as his 1656 *Maids of Honour (Las Meninas)*, in the Museo Nacional del Prado, Madrid.

FRANCE

Under an increasingly autocratic Louis XIV (r.1661–1715), France became the most powerful nation in Europe. An intellectual revolution enforced the idea of knowledge through observation rather than divine revelation, eventually leading to The Enlightenment. The Académie Royale de Peinture et de Sculpture (Royal Academy of Painting and Sculpture), created in Paris in 1648, enabled the king to control the arts in France. Yet conflict developed within the Academy between those who favoured the colour and drama of Rubens (page 100), called *rubénistes*, and those, called *poussinistes*, who preferred a style of line and calm, exemplified by the paintings of Nicolas Poussin.

Louis XIV constructed a vast royal palace at Versailles, southwest of Paris. The government of France was based there, home to up to 10,000 people, thereby centralizing power around the king, undermining the strength and authority of the French nobility. The setting for the self-proclaimed Sun King's state

Diego Velázquez
The Lunch,
c.1617
Oil on canvas,
108.5 x 102 cm
(42¾ x 40⅛ in.)
Hermitage Museum,
St Petersburg

Velázquez comfortably
combines a group portrait
of everyday people with a
still life painting.

events was the Hall of Mirrors (above), the name derived from the seventeen arched mirrors reflecting the seventeen arched windows that look out on the vast formal gardens. One of the most spectacular rooms in the palace, the intent of this décor was to impress – if not dazzle – the guests.

ENGLAND

After the Great Fire of London in 1666 destroyed large portions of the city, a commission formed to undertake the necessary reconstruction. Among its members was the multi-talented architect Sir Christopher Wren (1632–1723). Although the commission rejected Wren's master plan for rebuilding London, he was chosen as the architect of the new St Paul's Cathedral (opposite), built 1675–1710. The façade of St Paul's represents the classicizing trend within the Baroque style, for while Roman antiquity is the source of certain features – the dome, pediment and columns – they are used in a more dramatic Baroque way by lifting the dome on double drums, raising the pediment high on a second storey and pairing the columns, as well as adding the two framing towers.

Jules Hardouin-Mansart, Charles Le Brun and Antoine Coysevox
Palace of Versailles, Hall of Mirrors, c.1680
L. 73 m (240 ft), w. 10.4 m (34 ft), h. 13 m (43 ft)

A variety of materials, illuminated by innumerable candles and enhanced with solid silver furniture, elegantly embellished this tunnel-like space.

Sir Christopher Wren
St Paul's Cathedral,
London, façade,
1675–1710
L. 156.67 m (514 ft),
w. 76.20 m (250 ft),
dome h. 111.56 m (366 ft)

This is not a false façade;
rather it indicates the
division of spaces. The
lower arcade corresponds
to the width of the nave
and aisles, while the
upper columns beneath
the triangular pediment
correspond with the
width of the nave.

18th-century Rococo and Neoclassical art

What was the impact of the discovery of Pompeii and Herculaneum on the transition from Rococo to Neoclassicism?

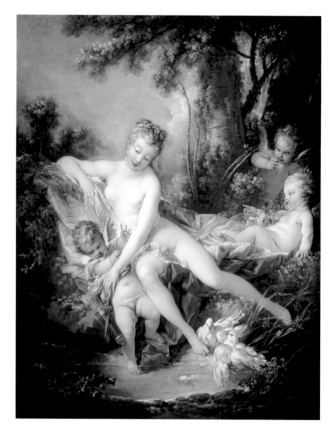

François Boucher
Venus Consoling Love,
1751
Oil on canvas,
107 x 84.8 cm
(42⅛ x 33⅜ in.)
National Gallery of Art,
Washington, DC

Boucher specialized in paintings of elegantly refined erotica to satisfy the pleasure-seeking tastes of the nobility and royalty. Madame de Pompadour owned this painting and may have been the model.

The 18th century saw changing world views. The Age of Enlightenment in Europe, 1715–89, expanded Renaissance humanism's focus on the individual to include reasoning based on evidence received through the senses. Adoption of the scientific method resulted in advances in chemistry, physics, mathematics,

astronomy and medicine. The concept that liberty, fraternity and equality went together was a basic tenet of Enlightenment philosophy, as was religious tolerance. The unearthing of the ancient Roman cities of Pompeii and Herculaneum renewed focus on classical art, architecture, literature and philosophy.

ROCOCO

The term Rococo probably derives from *rocaille*, French for a type of decoration made with pebbles and shells used in garden fountains and grottos. Rococo may be regarded as the Baroque scaled down – in size, bravura and drama.

Artists turned away from religious subjects to romance, lightening the message, mood and palette to pastel tones

The favourite subject of painters and sculptors was the female figure, preferably unclothed, whether or not required by the context.

France

Upon Louis XIV's death in 1715, the throne passed to his great-grandson, Louis XV (1710–74), then only five years old. Louis XV's long reign was marked by the first stirrings of resistance to autocratic rule by the nobility and upper classes and continuing conflict with England. By the end of the century, France had lost its North American holdings.

The Rococo is associated especially with the era of Louis XV. Among his various mistresses, the favourite was Jeanne Antoinette Poisson (1721–64), better known as Madame de Pompadour, who influenced the King's political decisions and encouraged the arts. She was a supporter of the witty writer Voltaire (1694–1778) and other philosophers of the Enlightenment. Madame de Pompadour's preferred painter was François Boucher (1703–70), who was appointed first painter to the King and director of the Royal Academy in Paris.

Boucher's painting of *Venus Consoling Love* (opposite), of 1751, is characteristic of both his work and contemporary taste. The ideal woman was soft, delicate, pale and naked – except for her jewels. The purpose of the mythological association with Venus, the Roman goddess of love, is to make the salacious subject acceptable in polite

Élisabeth Louise
Vigée Le Brun
*Marie Antoinette
with a Rose,*
1783
Oil on canvas, 113 x 87 cm
(44½ x 34¼ in.)
Musée de l'Histoire de
France, Versailles

Because Vigée Le Brun
associated closely with
the French queen and
court, she wisely left
the country during the
French Revolution and
would paint in various
European countries.

society. A search for an edifying moral or message here will prove fruitless.

In 1774 the throne passed to Louis XVI and his queen, Marie Antoinette, who was portrayed several times by her court painter, Élisabeth Louise Vigée Le Brun (1755–1842), whose father was an artist specializing in pastel portraits. When he died in 1767, she was able to support her mother and brother through the sales of her paintings, despite her youth. People clamoured to pose for her when she was only twenty. Her clientele included leading members of the aristocracy and she charged more for her portraits than any other portraitist in France. In addition to the virtuosity of her technical skill, sumptuously rendered textures and fine colour harmonies, her success came especially from her ability to portray in her sitters an elegant charm, with self-assurance and a sense of elevated nobility. Portrait painter to royalty, Vigée Le Brun left for posterity records of the appearance of many of the most prominent people of her time (opposite).

Great Britain

Early in the 18th century, England and Scotland united to form Great Britain. By the middle of the century the stage was set for the Industrial Revolution of the late 18th and early 19th centuries. Basic machines and scientific tools (such as the thermometer, steam engine and steamboat) were either created or improved to the point of practical application. Increased agricultural productivity supported population growth, which provided workers for the new factory system.

The many wars with France over the course of the 18th century drained the economy, but Britain became the world's largest trading nation largely due to its powerful navy. By the end of the century Britain had lost its rebelling American colonies with which there had been a profitable trading relationship. The colonies in Canada, Australia, New Zealand and the Caribbean and trading posts in India and other parts of the globe remained.

Historians debate whether the ideas of the French Enlightenment crossed the Channel to England, where individualism and liberty were highly valued, but equality and fraternity less so. Class distinctions and divisions were strongly felt and honoured, not without class conflict.

The satirist William Hogarth (1697–1764), born in London, was active in the same years that the Rococo style flourished in France. But rather than depicting the aristocracy as elegant and appealing, Hogarth focused on the failings of English society. He painted

his progressive ideas in series of scenes that offered moralizing messages made memorable through engaging narratives. Like Dürer, Hogarth also produced inexpensive prints in multiple copies, which spread his ideas.

Hogarth's *Marriage à-la-Mode* series consists of six paintings, made 1743–5, that tell a tale of greed and vanity in a marriage arranged by two fathers for their own benefit. In the first scene a nobleman trades his social position with a tradesman for money to pay his mortgage. The following scenes show the marriage quickly falling apart, especially when the husband contracts a venereal disease from his child-like mistress. While the wife's hair is coiffed (above), she ignores everyone present to entertain her, instead giving her attention entirely to the lawyer/lover aptly named Silvertongue. The husband catches his wife with her lover, a fight ensues and Silvertongue fatally wounds the husband. The last scene makes the disastrous results of this marriage of convenience clear, for the husband and lover are dead and the wife takes poison.

Satirists active in England took aim at a variety of problems, including people's baseless beliefs about scientific advancements. This is the subject of *The Cow-Pock—or—the Wonderful Effects of the*

William Hogarth
The Toilette (The Countess's Morning Levee), scene 4, *Marriage à-la-Mode*, c.1743
Oil on canvas,
69.9 x 90.8 cm
(27½ x 35¾ in.)
National Gallery, London

This scene, atypically for its time, includes non-Caucasians. An African man in European attire brings a beverage. England, especially London, had a large African population in Hogarth's time, some enslaved, others free.

New Inoculation! (below), an etching by James Gillray (1756–1815). The first ever vaccine was developed in 1796 by the British doctor and scientist Edward Jenner against smallpox, a disease endemic to 18th-century Europe. Characterized by a high fever and rash that developed into blisters, smallpox killed up to eighty percent of those infected or approximately 400,000 Europeans annually. Jenner's breakthrough came when he observed that milkmaids who had had cowpox never caught smallpox. Jenner's method became known as 'vaccination', from the Latin *vacca*, meaning cow.

From its inception, vaccination had vociferous opponents, as illustrated by Gillray's animated, agitated caricatured crowd. Inoculated people are shown sprouting cow horns, having cows erupt from various parts of their anatomy and even giving birth to tiny calves. On the back wall hangs a painting of the biblical golden calf, a warning against the new form of bovine idolatry.

Society portraiture, popular in 18th-century England, demonstrated the importance accorded to one's position in the social structure. The rival English portraitists Sir Joshua Reynolds and Thomas Gainsborough both painted in the style known as the Grand Manner. At first Gainsborough (1727–88) painted landscapes, his preferred subject, but portrait painting, at which

James Gillray
The Cow-Pock—or—the Wonderful Effects of the New Inoculation!
1802
Hand-coloured etching, 26 x 36 cm (10¼ x 14⅛ in.)
The Art Institute Chicago

Gillray satirizes the ongoing fear and lack of understanding of this new medical treatment.

The Cow Pock — or — the Wonderful Effects of the New Inoculation! — vide the Publications of ye Anti-Vaccine Society.

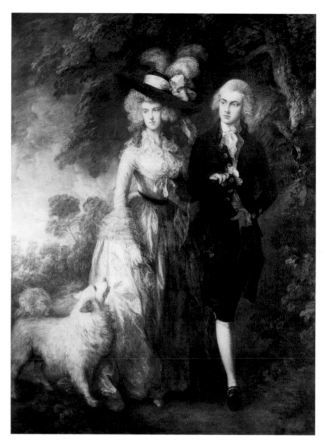

Thomas Gainsborough
Elizabeth Stephen and
William Hallett (The
Morning Walk),
1785
Oil on canvas,
2.36 x 1.79 m
(7 ft 9 in. x 5 ft 10 in.)
National Gallery, London

The Grand Manner of
18th-century English
portraiture favoured
poses and other features
derived from ancient
Roman or Renaissance
art for their lofty
implications.

he excelled, paid well and he became England's most sought-after portraitist. Paintings such as the double portrait of *Elizabeth Stephen and William Hallett (The Morning Walk)*, 1785 (above), which depicts his subjects exactly as they wished to appear, explain his success. Gainsborough records the fashionable, elegant couple shortly before their marriage, strolling through a puffy pastel Rococo landscape. They display the social graces admired at the time, enhanced by Gainsborough's complete technical control using fluid paint, rich colours and luxurious textures.

NEOCLASSICISM

By the late 1760s, the pendulum of taste started to swing away from the frivolity of Rococo art, which gave visual form to the pursuit of pleasure among the upper classes, and towards more serious

subjects conveying moral messages. The discovery and excavation of the ancient Roman cities of Herculaneum in 1738 and Pompeii in 1748 spurred interest in ancient Roman culture.

France

As France had been a leader in the Rococo style, it now assumed comparable prominence in the new Neoclassical style, exemplified by Jacques-Louis David (1748–1825), born in Paris. His *Oath of the Horatii* (below), commissioned by Louis XVI, is an intellectual antidote to Rococo gaiety. David had studied in Rome and the subject comes from ancient Roman history. The Horatii, three brothers from Rome, will fight the Curatii, three brothers from Alba. Their father holds their swords, demonstrating his support for them. David portrays patriotism as more important than self or family. When exhibited in 1785, this painting was widely considered to be critical of a monarchy that lacked the virtues depicted – even though the King had commissioned the painting.

The sculptor Jean-Antoine Houdon (1741–1828) was born at the Palace of Versailles (page 106) while his father was employed there as a servant. After the Académie Royale de Peinture et de Sculpture in Paris hired his father as a caretaker, the eight-year-old Houdon would slip into class unnoticed, snatch some clay and copy the students.

His fame as a skilled portrait sculptor was so widespread that Americans Benjamin Franklin (1778/9), John Paul Jones (1780) and Thomas Jefferson (1789) posed for Houdon while they were

Jacques-Louis David
Oath of the Horatii,
1784
Oil on canvas,
3.29 x 4.25 m
(10 ft 9 in. x 14 ft)
Musée du Louvre, Paris

David used an ancient Roman subject to encourage French patriotism and strict public morality.

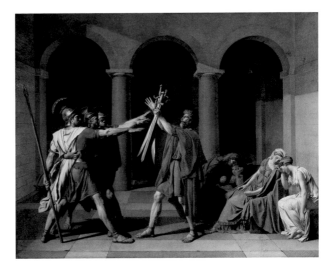

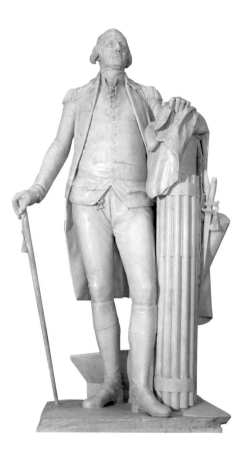

Jean-Antoine Houdon
George Washington,
signed 1788
Marble, h. 1.88 m
(6 ft 2 in.)
State Capitol,
Richmond, Virginia

**Neoclassical sculptor
Houdon returned to the
ancient Roman style of
highly naturalistic stone
portraits of political
leaders – such as that of
the Emperor Augustus
(page 39), c.20 BCE – for
this portrait of America's
first president.**

in France. Franklin and Jones were seeking a French alliance for
the rebelling British colonies; Jefferson represented the new nation
after its independence. To create a likeness of George Washington
(above), Houdon travelled to America, where he was Washington's
house guest in 1785. He did the preparatory work there but
carved the stone, life-size figure back in Paris, 1788–92. Although
Washington wears late 18th-century clothing, the iconography
refers to Roman antiquity. Under his left arm are thirteen wooden
rods tied together, which represent the original states of the Union
as well as *fasces* (singular *fascis*), used in ancient Rome to indicate
political power.

England
Interest in antique architectural models appeared early in the
18th century at Chiswick House in west London (opposite),
designed in 1729 by Lord Burlington (1694–1753) and William Kent

(1685–1748). The style is referred to as Palladian after the 16th-century Italian architect Andrea Palladio. Breaking away from the large scale and drama of Baroque architecture, and the abundant ornament of Rococo architecture, Neoclassical architecture returns to the ideas of Roman antiquity. Chiswick House is austere, the scale of this private home liveable, the decoration minimal.

In addition to Chiswick House, other progeny of the Pantheon (page 42), with its central dome and pediment supported on a columnar porch, are found widely across western Europe and the United States, including its namesake, the Panthéon in Paris, built 1758–90 and Monticello, the home of Thomas Jefferson (1743–1826), in Charlottesville, Virginia, which he designed in 1769 and built 1770–1806.

KEY IDEAS

Renaissance: Early and High Renaissance periods in Italy and northern Europe follow similar trajectories as ancient Greek and Roman ideas combine with a new view of the world.

Mannerism: Replacement of Renaissance clarity with Mannerist distortion coincides with political upheaval.

Baroque: Visual drama and emotion, promoted by the Church, spreads from Rome across western Europe.

Rococo: The pendulum swings towards sensual pleasures reflecting the tastes of the upper class.

Neoclassical: A reaction against Rococo frivolity, the Neoclassical era is spurred by the rediscovery of Pompeii and Herculaneum.

Lord Burlington and William Kent
Chiswick House, west London, designed 1729

The inspiration for this house can be traced back through Palladio's Mannerist 16th-century Villa Rotunda in Vicenza and ultimately to the ancient Roman Pantheon (page 42).

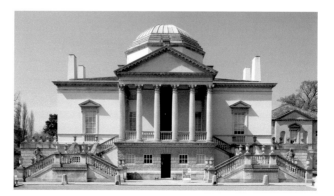

ROMANTICISM
TO TODAY

-

Interest in freeing art from earlier restrictions
increases, as does contact between countries
and cultures, producing a global approach
to the arts

-

Romanticism, Realism, Impressionism and Post-Impressionism
Does political and social upheaval stifle or stimulate the creative arts?

The 19th century, a time of war and revolution, opened with continued conflict between revolutionary France and monarchical Europe, followed by political revolutions in France, Germany and Belgium seeking greater popular influence in government. Scientific, medical, agrarian and industrial revolutions resulted in a shift from rural to urban life, and higher living standards. By the end of the century, Europe's population had doubled, even after allowing for mass emigration. France was enjoying a period of peace,

economic growth and optimism – its Belle Époque – recorded by the Impressionist and Post-Impressionist painters. America was in its Gilded Age and Britain was in the final years of Queen Victoria's reign.

The Napoleonic Wars involved a kaleidoscope of alliances and coalitions, but always featured Great Britain on one side and France on the other. In 1799, Napoleon, France's greatest general, took control of the country as First Consul. In 1804, he crowned himself Emperor of the French and by 1809 had established hegemony over most of Europe, spreading the Revolution's ideals of liberty, equality and fraternity across the continent.

Francisco Goya
The Second of May
1808 (The Charge of
the Mamelukes),
1814
Oil on canvas,
2.69 x 3.48 m
(8 ft 9 in. x 11 ft 5 in.)
Museo Nacional del
Prado, Madrid

**Filled with emotion
and commotion, Goya's
painting dramatically
records the savagery
of battle as the French
cavalry unit – the
Mamelukes, mostly
drawn from the Middle
East – attempt to subdue
the Spanish citizens of
Madrid.**

ROMANTICISM

As the pendulum of taste continued to swing, Neoclassicism was superseded by Romanticism. Rather than a visually distinct 'style' in the usual sense, Romanticism was a way of thinking. Focus was now on emotions, on feelings, on the subjective, on dreams. Inspiration might come from actual events, Nature's beauty or her destructive side, or distant exoticisms.

Spain

The Peninsular War between, on the one hand, France and initially Spain, and on the other, Britain allied with Portugal, began in 1807 as Napoleon invaded Portugal through Spain, seeking to stop trade between Portugal and England. Napoleon's forces, although at first allied with Spain, slowly occupied that country, entering Madrid in May of 1808.

Francisco Goya (1746–1828), a popular society portraitist in Madrid, became court painter to Charles IV of Spain in 1789. In addition to royal family portraits, however, Goya produced anti-war paintings and prints, and he sympathized with the ideals of the Enlightenment and the French Revolution. Goya initially supported the French presence in Spain, but on 2 May 1808 Madrid's citizens fought back against the French occupation, dramatically depicted in Goya's *The Second of May 1808* (opposite). Goya's subsequent painting *The Third of May 1808* (Museo Nacional del Prado, Madrid) graphically depicted the retaliatory execution of Spanish hostages by one of Napoleon's generals. The paintings were not actually created until 1814 when Goya had ceased to support the French occupation. He had hoped Spain would be modernized but, instead, his country was ravaged.

Eugène Delacroix
The Twenty-Eighth of July;
Liberty Leading the People,
1830
Oil on canvas,
2.59 x 3.25 m
(8 ft 6 in. x 10 ft 9 in.)
Musée du Louvre, Paris

**Delacroix's Romantic
depiction of the
Revolution of 1830
includes the various
members of Parisian
society active in
the Revolution, led
by Marianne, the
personification of French
liberty, raising the tri-
colour flag of France.**

France

In 1815, a coalition of Britain, Prussia and Russia defeated Napoleon
at Waterloo and re-established the French monarchy under
Charles X. However, many of the Revolution's changes remained in
place, creating political conflict between the returning conservatives
and the populace. On 28 July 1830 this discontent led to a second
revolution with fighting in the streets of Paris.

French Romantic painters such as Eugène Delacroix (1798–
1863) used art in the service of social and political causes. He
immediately painted *The Twenty-Eighth of July; Liberty Leading the
People* (above) in support of this revolution led by the working class.
The painting is a Romantic mixture of fact – the people did build
barricades using the cobblestones from the streets – and fantasy –
Liberty and the view of Paris seen through the smoke.

A revolution in 1848 resulted in the declaration of a republic
led by Louis-Napoleon Bonaparte, Napoleon's nephew. In 1851,
Louis-Napoleon seized control of the government and declared the
Second Empire, proclaiming himself Emperor Napoleon III. The
Second Empire was marked by the redesign and renewal of Paris,
directed by the urban planner Georges-Eugène Haussmann (1809–
91), which included wide boulevards, parks and strict regulation of
new construction to foster consistency. However, Napoleon III
engaged in the disastrous Franco-Prussian War, 1870–71, which led
to his abdication and the French Third Republic.

Germany and Great Britain

Elsewhere, rather than political subjects, Romantic painters turned to nature. Perhaps the epitome of Romanticism in Germany, Casper David Friedrich (1774–1840) painted evocative landscapes, misty and desolate. His best known work is *Wanderer above the Sea of Fog*, c.1817 (Kunsthalle, Hamburg).

In Great Britain, Princess Victoria of Kent was crowned Queen in 1837. Her long reign (until 1901) was marked by internal stability that coincided with a focus on social morality, colonial expansion and innovation in science, medicine and industry. Industrialization, begun in textile, iron and coal manufacture in Britain in the 18th century, continued apace in the 19th century with the application of steam engines to factories and transportation. Development of networks of railroads, canals and roads improved communications, as did the introduction of telegraphy. Later in the century, new technologies such as electric light and power appeared.

English artist James Mallord William Turner (1775–1851) romanticized the new steam engine in his painting *Rain, Steam and Speed – The Great Western Railway* (below). Turner glorifies this aspect of the Industrial Revolution, a subject new to art.

J. M. W. Turner
Rain, Steam and Speed –
The Great Western
Railway,
exhibited 1844,
perhaps painted earlier
Oil on canvas, 91 x
121.8 cm (36 x 48 in.)
National Gallery, London

**Turner's backgrounds
in watercolour and
landscape painting merge
in imaginary scenes of
modern industrialization.**

Foreshadowing the Impressionists, Turner was concerned with light, atmosphere and weather conditions, but, rather than taking a factual approach, he created a Romantic image of soft forms and blended tones achieved by layers of fluid oil glazes. His paintings were described as 'tinted steam' and for his unusual style he was dubbed 'the over-Turner'.

REALISM

France

Located initially in France, especially in Paris and the surrounding area, Realist artists tried to portray the realities of life through objective, non-idealized visual description. Subjects were now ordinary, everyday aspects of life, putting the Realists at odds with the traditional subjects approved by the Paris Salon, the official art exhibition run by the French Academy: namely history, religion and mythology and, to a lesser extent, landscape and still life.

Édouard Manet
Le Déjeuner sur l'herbe
(Luncheon on the Grass),
1863
Oil on canvas,
2.07 x 2.65 m
(6 ft 9 in. x 8 ft 8 in.)
Musée d'Orsay, Paris

Manet painted this in his studio from models. The composition of the three figures is based on a print by Marcantonio Raimondi after a painting by Raphael, c.1520, of the *Judgment of Paris*.

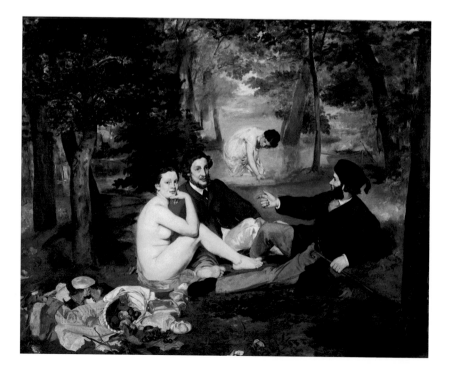

Also contrary to the smooth surfaces with imperceptible brushstrokes favoured in academic painting was the Realists' free painting method with visible brushstrokes

Édouard Manet (1832–83), scion of a wealthy French family, had a traditional academic training in art. In 1863, the year he painted *Le Déjeuner sur l'herbe* (*Luncheon on the Grass)* (opposite), the Salon jury turned away so many paintings that Napoleon III authorized a second Salon known as the Salon des Refusés (Salon of the Rejected). Yet even here *Le Déjeuner sur l'herbe* was shocking because it depicts a recognizable, unidealized naked woman outdoors with two clothed men and was believed by the public to record an actual event.

Not only did Manet's subject break from those approved for traditional academic painting, but deemed even more offensive was his painting style. Having no intention of duplicating observed reality, rather than employing linear and atmospheric perspective and subtle modelling to create an illusion of three-dimensionality, Manet favoured large areas of nearly solid colours, with abrupt dark outlines further flattening the effect, the large brushstrokes creating simplified rather than detailed forms. His ideas and methods would lead to Impressionism.

America

Early in the 19th century the United States benefitted greatly from the purchase of a major portion of the North American continent from France, as well as from increased trade. Exploitation of the new land led to heightened friction with the indigenous peoples and exacerbated political conflict over the expansion of slavery.

Perhaps the most significant cause pursued during the 19th century was the abolition of slavery. In America slave labour was the basis of the lucrative cotton industry, the country's major export. Great Britain abolished the slave trade in 1807 and slavery in its dominions (except India) in 1834. France followed in 1848. The United States required a four-year Civil War, between the Union – the Northern states seeking its abolition – and the Confederacy – the Southern states, which seceded from the United States in an effort to retain slavery. When the North finally won in 1865, slavery was abolished throughout the United States.

America's Civil War spurred the Realist style, with artists favouring themes from contemporary life but using traditional

Winslow Homer
Home Sweet Home,
c.1863
Oil on canvas,
54.6 x 42 cm
(21½ x 16½ in.)
National Gallery of Art,
Washington, DC

**Homer was praised for
his visual narratives of
people's daily lives and
their emotions.**

painting techniques. The illustrator and painter Winslow Homer
(1836–1910) documented the Civil War for *Harper's Weekly* journal
and in oil paintings such as *Home Sweet Home*, c.1863 (above).
Homer's images may convey a sense of longing and nostalgia, yet
they are factual rather than sentimental. This painting of soldiers in
camp as dusk approaches was lauded by a contemporary critic for
the powerful yet poignant emotion conveyed by the men as they
listen to the band and their thoughts turn away from battle to
'home sweet home'.

IMPRESSIONISM
In the same years that America enjoyed its Gilded Age
(1870s–c.1900), France's affluence engendered the Belle
Époque (1871–August 1914). This period of industrialization and

expansion led to great wealth for some and a rising standard of living for many. France was prosperous and peaceful, creative and dynamic. Coinciding with the rise of democracy and decline of authoritarianism, progressive artists opposed established juried exhibitions and traditional painting styles. Impressionism centred on Paris and the surrounding Île-de-France. Continuing to focus on the subjects favoured by the Realists, Impressionists depicted their immediate surroundings.

–

Favoured subjects were scenes of pleasant pastimes and places where people gather such as the cafe, opera, theatre or race track, as well as landscapes and still lifes

–

The word 'Impressionism' comes from *Impression, Sunrise* (below), a view of the harbour at Le Havre painted in 1872 by Claude Monet (1840–1926). Artists had long covered their white gessoed canvases with a uniform brown ground, then worked up to lighter colours. The Impressionists eliminated the ground and painted directly on the white surface. The result was lighter, brighter paintings than those of

Claude Monet
Impression, Sunrise,
1872
Oil on canvas,
50 x 65 cm
(19¾ x 25⅝ in.)
Musée Marmottan
Monet, Paris

Taking Manet's visible brushstrokes still further, Monet's application of paint is loose and sketchy, giving the viewer an impression of what the artist saw rather than every detail.

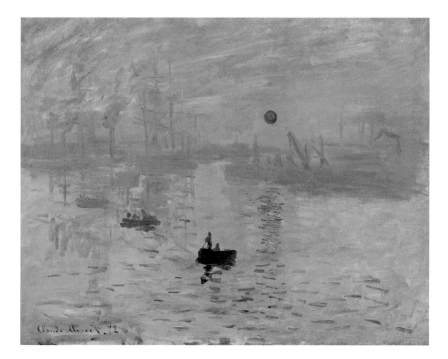

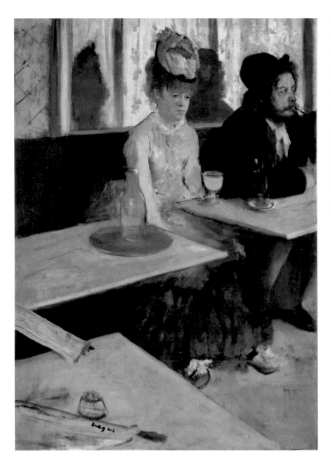

Edgar Degas
*L'Absinthe (The
Absinthe Drinker)*,
1875–6
Oil on canvas,
92 x 68.5 cm
(36¼ x 27 in.)
Musée d'Orsay, Paris

**Although carefully
staged in Degas's studio,
this scene was typical of
the bohemian cafés of
Paris. A woman, tired and
dishevelled, isolated from
her companion, sits with
her glass of absinthe.**

any other style – with the possible exception of the French Rococo
(page 109). Seeking to capture the effect of changing natural light,
the Impressionists painted outdoors, a choice now made practical by
the introduction of oil paint in small, easily carried tins and tubes.

In order to study light and colour, Monet painted the same subject
multiple times, be it the façade of Rouen Cathedral, poplar trees or
haystacks. The subject did not change, but the weather, atmosphere,
season and time of day did. These intangibles were his real subject,
which he recorded using the technique of '**broken colour**', in which
any one colour is made up of little dabs of its component colours.

The Impressionist painters organized a group exhibition of their
work in 1874. The major Impressionists – Claude Monet, Mary
Cassatt, Berthe Morisot, Camille Pissarro, Pierre-Auguste Renoir,
Alfred Sisley and Edgar Degas – participated.

Edgar Degas (1834–1917), an aristocrat from a wealthy banking family with a nasty wit and extremely conservative views, was disliked by many of the other painters. His strict academic training led to a style based on line, in contrast to Monet's preference for colour. Degas was called a 'linear Impressionist', perhaps an oxymoron. He worked slowly and methodically, yet achieved a sense of casual spontaneity. In this, he was aided by photography.

His favourite subjects were ballet dancers – not on stage, but behind the scenes, often at their least graceful. Degas also depicted working-class people and their daily lives, in which alcohol, the subject of his painting *The Absinthe Drinker*, 1875–6 (opposite), played a significant part for many.

Absinthe was an extremely popular drink throughout Europe and especially France in the late 19th century. This potent liquor contained up to 75% alcohol. Originally used as a herbal remedy, the active ingredient is wormwood (the chemical thujone), a nervous system stimulant which in sufficient quantities causes convulsions, and chronic heavy consumption leads to death. As absinthe drinking grew, its harmful effects led to a public health crisis. Those who drank it were stereotyped as morally degenerate and absinthe intoxication was blamed for terrible crimes.

Degas's painting *L'Absinthe* was seen as an indictment of the drink. While there was general agreement that the painting was an accurate portrayal of the empty desolation brought by absinthe addiction, it was denigrated by critics of the day. Many considered the subject too repulsive to be considered 'fine art'.

In addition to French Impressionist painters, there were American Impressionists in France. Perhaps the most notable was Mary Cassatt (1844–1926), who studied art in the United States but then left her wealthy Philadelphia family and settled in Paris. There Degas befriended her and, at his invitation, she exhibited with the Impressionists. Characteristic of Cassatt's work is her *Mother About to Wash Her Sleepy Child*, 1880 (overleaf), for her favourite subject was the mother and child, shown in intimate, endearing scenes. Cassatt was praised for her skill in drawing; even misogynistic Degas said he never would have believed a woman could draw so well.

Nineteenth-century sculpture generally followed the same sequence of styles as painting. Two French sculptors, Auguste Rodin (1840–1917) and Camille Claudel (1864–1943), focused on the body as a vehicle for meaning and emotion. So closely were their lives and art connected that their styles were nearly indistinguishable. Initially Claudel was Rodin's student, but they

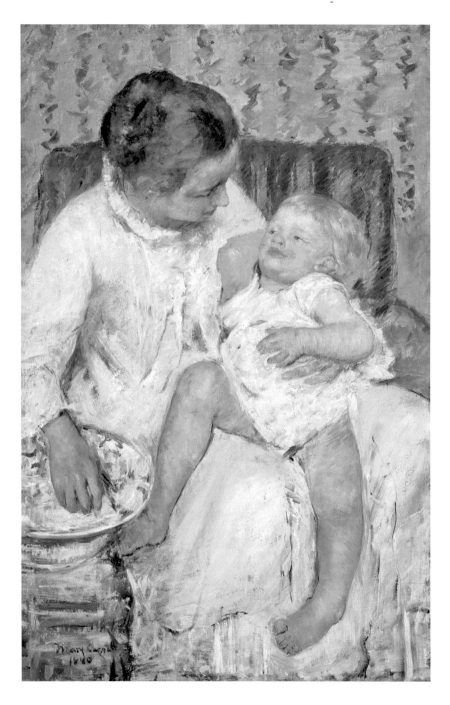

**Auguste Rodin and
Camille Claudel**
Burghers of Calais,
1884–95
Bronze, figures
h. 2 m (6 ft 6 in.)
Philadelphia Museum
of Art

The story of this
historical event comes
from Jean Froissart's
14th-century *Chronicles*
and tells of the surrender
of Calais to the English
King Edward III in
1347. The poses and
gestures convey powerful
sensations, from anguish
to resignation.

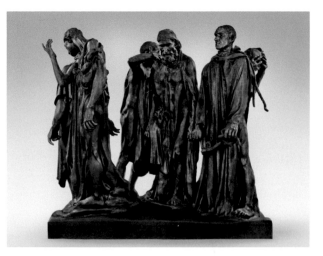

Opposite: Mary Cassatt
*Mother About to Wash
Her Sleepy Child*,
1880
Oil on canvas,
100.3 x 65.7 cm
(39½ x 25⅞ in.)
Los Angeles County
Museum of Art,
California

An American in Paris,
Cassatt was able to realize
her potential as an artist
there. She encouraged
her wealthy American
friends to collect French
Impressionist paintings,
thereby exposing
Americans – including
artists – to progressive
Impressionist ideas.

became collaborators and lovers. Claudel sculpted the powerfully
expressive hands and feet of Rodin's *Burghers of Calais* (above),
a monument to the selfless heroism of six citizens of Calais who
voluntarily offered themselves for execution to save their city
from destruction by the English during the Hundred Years War.
To enhance the realism and relevance, Rodin's models were from
Calais. His original plan was to place the figures one after another
across the city square, at or near ground level; the intended
installation might have been far more effective, even startling,
than their current elevated position.

Claudel, although long eclipsed by Rodin, was his artistic equal.
Due to her declining mental state, she lived in an institution
for the last three decades of her life – contrary to doctors'
recommendations, but at her family's insistence.

POST-IMPRESSIONISM

Beginning in France in the 1880s, Post-Impressionism includes
a variety of painting styles. It was not a rejection or repudiation
of Impressionism. Rather, it was a somewhat different approach
to related subject matter in an effort to enhance and enrich
Impressionism by seeking less objectivity and more personal
interpretation. The artist's thoughts and emotions were to be given
visual form. Additionally, greater emphasis was placed on pictorial
structure and composition as a way to interpret and modify the
visual world rather than only record what the eye sees.

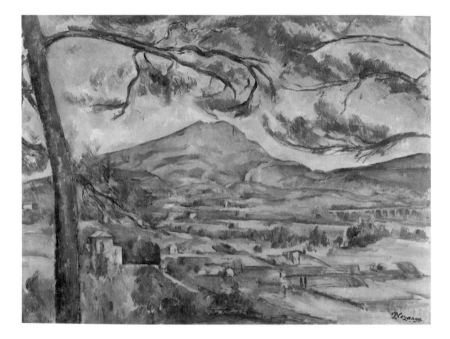

Post-Impressionist painting is represented by two different approaches. Paul Cézanne and Georges Seurat worked slowly and methodically, making many preliminary studies and using colour for structure. Vincent van Gogh and Paul Gauguin created emotionally expressive paintings through their use of colour to convey feelings.

Paul Cézanne (1839–1906) was born, lived most of his life and died in Aix-en-Provence. Family wealth allowed him the freedom to paint without the need to please customers. This was fortunate as he was reclusive and lacking in social skills. His wife, Marie-Hortense Fiquet, whom he married when their son was a teenager, was said to be the only person able to endure posing for him. This had to do not only with his personality but also with his slow painting method, taking as much as twenty minutes between brushstrokes. Carefully constructing his paintings, Cézanne explained that he tried 'to make of Impressionism something solid and durable, like the art of the museums'.

Cézanne preferred to paint still lifes and landscapes; the latter may be considered an enlarged version of the former, and neither subject would require him to make conversation. *Mont Sainte-Victoire with Large Pine* (above), c.1887, is among several paintings he made of this mountain near his home and studio in Aix. Cézanne employed his 'little planes', as he called his brushstrokes, to build

Paul Cézanne
Mont Sainte-Victoire with Large Pine,
c.1887
Oil on canvas, 67 x 92 cm
(26⅜ x 36¼ in.)
Courtauld Gallery,
London

In a letter Cézanne wrote to Émile Bernard in 1904, he said his approach was to 'deal with nature by means of the cylinder, the sphere and the cone, all placed in perspective'.

the composition. The tree trunk and branches mark the foreground, yet those branches mimic the outline of the horizon, compelling the viewer's eyes to fluctuate between near and far, thereby flattening the pictorial space.

Cézanne was never satisfied with his painting and never felt he had achieved his goal, saying, 'I am the primitive of the way I have discovered.' Yet his approach and his 'little planes' led to the development of Analytical Cubism by Pablo Picasso and Georges Braque, which was key to early 20th-century innovations.

Georges Seurat (1859–91) was still more methodical than Cézanne. Taking the Impressionists' idea of broken colour further, Seurat analysed the exact component tones that make up what our eyes perceive to be a single colour and then applied them in tiny dots to his canvases. The technique is referred to as Divisionism, for the way in which each colour is divided into its components, or Pointillism, for the countless dots on his canvases. Seurat's most famous painting is *A Sunday Afternoon on the Island of La Grande Jatte – 1884*, painted 1884–6 (Art Institute of Chicago, Illinois).

Very different from slow, analytical, intellectual Cézanne and Seurat, Vincent van Gogh (1853–90) painted with great speed and emotion. Although born in the Netherlands, he created most of his paintings in France, where his younger brother Theo provided emotional and financial support. In Paris, Van Gogh met the Impressionists and abandoned his drab palette for their vivid colours, but used them to convey intense emotion. Van Gogh suffered from extreme emotional swings, frequently moved from town to town and had no lasting friendships. His art was neither understood nor appreciated during his lifetime. He painted *The Red Vineyard at Arles* in 1888 (overleaf), a landscape subject that usually creates a feeling of pleasant calm – unless painted by Van Gogh. Created with thick **impasto** rapidly applied in very visible brushstrokes, the effect is animated and agitated. The expressive use of unnatural colour includes blue trees, a yellow sky and red vines.

Van Gogh's lifestyle included self-destructive tendencies, most famously when he cut off most of his own left ear after an argument with Gauguin. The two artists, both with emotional temperaments, had lived together briefly in Arles. Believing himself a failure, Van Gogh died by suicide; he shot himself in the chest, lingered for a day and a half and died in Theo's arms.

Paul Gauguin (1848–1903) was born in Paris, his father French and his mother Peruvian. At the age of thirty-five, he abandoned a successful career as a banker and stockbroker, as well as his wife and five children, to become an artist living a quixotic, exotic life,

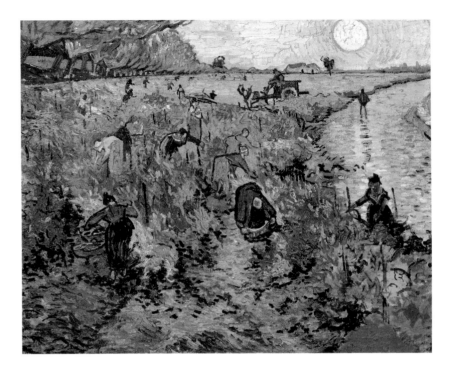

partly in French Polynesia, where he sought an unspoiled (and less expensive) way of life. Calling himself Monsieur Sauvage (Mr Savage), he painted in his wooden hut, naked, and learned the language and myths of this culture. His works, which exoticized and othered his non-European subjects, appealed to art collectors in Paris.

Both Van Gogh and Gauguin wrote about their use of certain colours to convey specific emotions. Gauguin's painting *Nafea Faa Ipoipo (When Will You Marry?)* 1892, (opposite), is a pattern of rich colours of great variety, some contrary to nature, which create a warm tropical sensation. He arranged colours and forms for balance and beauty, the crisp curving outlines forming decorative shapes across the surface rather than suggesting depth. Gauguin named this style **Synthetism**, identified by sharply edged areas of flat vivid colours. Because this style was used to translate abstract ideas into visual forms, it is also known as **Symbolism.**

Vincent van Gogh
The Red Vineyard at Arles,
1888
Oil on canvas, 75 x 93 cm
(29½ x 36⅝ in.)
Pushkin Museum of
Fine Arts, Moscow

This was one of the very few paintings Van Gogh ever sold, possibly the only one. It was bought by the Belgian painter Anna Boch for 400 francs in 1890.

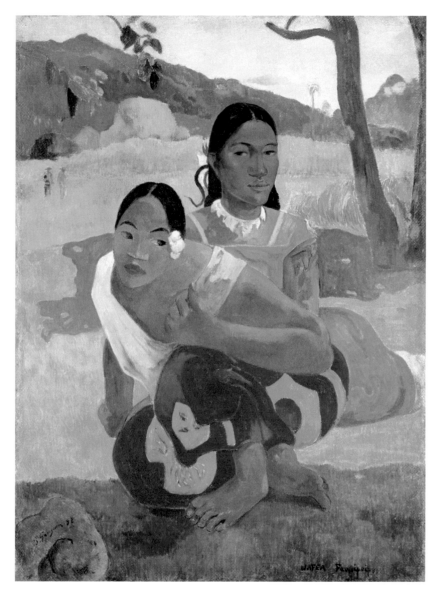

Paul Gauguin
*Nafea Faa Ipoipo
(When Will You Marry?)*,
1892
Oil on canvas, 101 x 77 cm
(39¾ x 30⅜ in.)
Private collection

Departing from the
academic approach in
favour of distorting colour
and shape to transform
them into symbols,
**Gauguin freed future
artists from the inhibiting
requirement to imitate the
visible external world.**

Earlier 20th-century art
What was the impact of the First World War on the visual arts?

The 20th century began with the optimism of the Belle Époque in France and the Gilded Age in the USA. The era came to an abrupt end in 1914 when the trip-wire of alliances among the 'Great Powers' set the First World War in motion. The twenty-year period of relative peace that followed the war included an economic boom and then a depression. This ended with a second, even more destructive, war, ushering in the Nuclear Age.

FAUVISM

The late 19th-century interest among artists in unnatural form and colour became progressively more pronounced in the early 20th century. Colour could correspond with what van Gogh called 'the artist's temperament' rather than copying reality. The unusually liberal 1905 Salon d'Automne (Autumn Salon) in Paris included a room of paintings by Henri Matisse and others with related styles. The French art critic Louis Vauxcelles reviewed the Salon exhibition and disapprovingly called these artists *Les Fauves* (The Wild Beasts) due to their vivid and wildly unnatural colours, smeared paint and lack of apparent refinement. In fact, the Fauves intentionally created paintings to disturb the viewer, visually and emotionally.

The French painters Henri Matisse (1869–1954) and André Derain (1880–1954) led the Fauves. Matisse left a promising career in law and finance to become an artist. At the 1905 Autumn Salon, he exhibited *Woman with a Hat* (San Francisco Museum of Modern Art, California), a portrait of his wife, Amélie Parayre, with brilliant unnatural colours smeared on the canvas. Matisse's *Le Bonheur de vivre* (*The Joy of Life*, opposite), painted soon after in 1905–6, also has few similarities with previous styles. Instead of painting with small brushstrokes, Matisse applied his contrasting colours in flat areas and did not consistently model the forms with highlights and shadows to suggest three-dimensionality. He often applied the paint unmixed and therefore at maximum intensity, in colours contrary to nature such as the pink sky and yellow lawn. Different types of lines, thick and thin, with sinuous curves and sensuous contours, define the undulating, rhythmic shapes. He distorted and simplified the human form; much is left out or merely implied.

Henri Matisse
*Le Bonheur de vivre
(The Joy of Life),*
1905–6
Oil on canvas,
1.77 x 2.41 m
(5 ft 10 in. x 7 ft 11 in.)
Barnes Foundation,
Philadelphia,
Pennsylvania

Matisse founded a new style that the critics and the public initially viewed as radical. Yet the colours and curves, the lounging and dancing nudes, convey the joy of life.

ABSTRACT ART

Gradually freed from copying the visible world in the late 19th and early 20th centuries, certain artists developed a form of art that had no identifiable subject. This abstract art is based less on what artists perceive through the eyes and more on what they conceive in their minds.

The Swedish painter and mystic Hilma af Klint (1862–1944) studied at the Royal Academy of Fine Arts in Stockholm and graduated with honours. She then painted portraits and landscapes in a naturalistic, highly representational style that sold well. Simultaneously, however, and unknown to the public, she also painted in an entirely different style that was abstract (overleaf), yet not without meaning.

Hilma af Klint
*Group I, Primordial
Chaos – No. 16,*
1906–7
Oil on canvas, 53 x 37 cm
(20⅞ x 14⅝ in.)
Guggenheim Museum,
New York

**Fearing that people were
not yet ready for her
non-figurative paintings,
af Klint's will stated
that they were not to be
exhibited until at least
twenty years after her
death. The public first
saw her abstract paintings
only in 1986.**

Credit for the first completely abstract paintings now goes to
af Klint for works created as early as 1906. Previously the Russian
Wassily Kandinsky (1866–1944) had been considered the founder
of abstract art due to paintings he made in 1910–11. Other artists
whose works include early abstract paintings are the Russian Kazimir
Malevich (1879–1935) and the American Georgia O'Keeffe (1887–
1986). Af Klint appears to have been unconnected with these
artists, who arrived at abstraction through gradually simplifying
the outer visual world. In contrast, af Klint created her form of
abstract art fully developed and as a response to the inner spirits she
said guided her. The paintings translate the spiritual messages she
received into a visual language, using abstract forms to make the
invisible spirit visible; af Klint sought the sacred through abstraction.

CUBISM

Cubism was the invention of two painters: Pablo Picasso and Georges Braque, both of whom arrived separately at the same conclusions about the nature of our experience of the world. They soon discovered one another's shared convictions and proceeded to work together for seven years until the outbreak of the First World War.

The Spanish artist Pablo Picasso (1881–1973) was a child prodigy and son of a professor of art. He would constantly search for new means of expression, repeatedly inventing new artistic styles and

Pablo Picasso
Ma Jolie (My Pretty One),
1911–12
Oil on canvas,
100 x 64.5 cm
(39⅜ x 25⅜ in.)
Museum of Modern Art,
New York

Picasso's art is never completely abstract, for even when it is not immediately apparent, each work contains an identifiable subject, in this case a young woman.

working in a range of mediums during his long life – ninety-one
years of vitality, energy, productivity and dramatic flair.

The most influential of these styles for the future of painting
was Analytical Cubism.

**In this new way of analysing form in space, the artist depicts each
figure or item in a painting from multiple viewpoints by breaking
the forms into fragments of basic geometric shapes**

Ma Jolie (*My Pretty One*), painted 1911–12 (previous page), is a
portrait of Picasso's then lover, Marcelle Humbert, whom he called
'ma jolie'. Picasso rendered her as a multitude of faceted, angular,
overlapping shards and painted the background space in the same
way, unifying the composition. He limited the colours mostly to
neutral hues to avoid distracting from this innovative approach.
The forms used in Analytical Cubism may be seen as an outgrowth
of Cézanne's 'little planes' (page 132). Louis Vauxcelles, who gave
Fauvism its name, later did the same for Cubism.

FUTURISM

Based especially in Italy before the First World War, Futurist artists
used Cubist aesthetics for a new purpose – to depict motion. The
Italian poet Filippo Marinetti (1876–1944) explained the concept
in his 'Manifesto of Futurism', published in 1909 in the French
newspaper *Le Figaro*. Futurists glorified aspects of modern life,
especially machines and vehicles, promoting danger and war.

In 1910, a group of painters, including Gino Severini (1883–
1966), signed a 'Manifesto of Futurist Painters'. Severini's painting
Red Cross Train Passing a Village, 1915 (opposite), conveys the train's
dynamism and speed through a multitude of faceted forms. In
Analytical Cubism the subject is immobile but the artist moves in
order to depict it from multiple viewpoints, whereas in Futurism
the subject moves but the artist does not.

The First World War, fought between the Central Powers
(Germany, Austria-Hungary, the Ottoman Empire and Bulgaria)
and the Allies (France, Britain, Tsarist Russia and, after 1917,
the USA), was a stalemate for most of its four-year duration.
The Russian Revolution began in 1917 and early in 1918 the new
Communist government withdrew Russia, now part of the Union
of Soviet Socialist Republics (USSR), from the war. The war ended

Gino Severini
*Red Cross Train
Passing a Village,*
1915
Oil on canvas,
90.2 x 116.8 cm
(35½ x 46 in.)
Guggenheim Museum,
New York

**Opposed to the past,
Futurism's 'Manifesto'
called for the destruction
of institutions of
education such as
'museums, libraries,
and academies'.**

in late 1918, after roughly twenty million military and civilian deaths, with the surrender of Germany and the Austro-Hungarian Empire.

The huge number of casualties and massive destruction of the Great War left many people disillusioned with existing governmental and social structures. Subsequent social change included voting rights for women in the major democracies and liberalization of social strictures. Populations relocated as new nation states emerged from former Empires. Urbanization, labour organization and industrialization increased. The era from 1918 to the Great Depression of 1929–30 was referred to as the Roaring Twenties in the USA, *les années folles* (The Crazy Years) in France, and, for a brief period, the Glückliche Zwanziger Jahre (Happy Twenties) in Germany.

Italy, however, did not share in the good times of the 1920s. The Futurists' discontent with the government was based on political instability, rising inflation, strikes and unemployment. Socialist parties and unions gained strength, as did a new type of political philosophy – Fascism. Conceived early in the war years by Benito Mussolini (1883–1945), Italian Fascism focused on nationalism, totalitarianism, a state-controlled economy and an expansionist foreign policy. Fascist groups soon emerged in other European countries.

Man Ray
Cadeau (Gift),
1921/1963
Hand iron, 14 tacks,
paint, wooden base,
15.3 x 9 x 11.4 cm
(6 x 3⅝ x 4½in.)
Cleveland Museum
of Art, Ohio

What sort of art does a satirical, anti-art art movement produce? The question is answered by Duchamp's *Fountain* and Man Ray's *Cadeau*. Both are Readymades – existing objects that are modified, removed from their intended context and unable to serve their intended function.

DADA

Deeply affected by the destruction, horrors and insanity of the war, artists, authors and musicians started a new movement. Known as Dada, the origin of the term, as well as where the style was started and by whom, is debated. One opinion is that it derives from 'da da', often a child's first words. Others claim that 'da da' means 'yes yes'. Yet Marcel Duchamp, a key figure in the Dada movement, said the word was French for hobby horse, arbitrarily chosen from a dictionary. Dada probably began with gatherings at the Café Voltaire in Zurich and developed separately in New York. Dadaists found no meaning or value in traditional aesthetics. They believed, instead, in imagination, chance and irrationality. Dada was an anti-art art movement with an anti-aesthetic aesthetic.

Key New York Dadaists included Marcel Duchamp and Man Ray. New York Dada may be said to begin when the French artist Marcel Duchamp (1887–1968) attempted to exhibit an upside-down porcelain urinal, which he titled *Fountain*, signed (but not with his own name) and dated 1917, as a work of art at the Independents exhibition held in New York. Politically motivated, the intent of Dada was to shock the public. Dada lasted from 1916 to 1924.

The Dadaist and Surrealist artist Man Ray (1890–1976) was born Emmanuel Radnitzky in Philadelphia but was active in New York and Paris. Akin to his friend Duchamp's Fountain, Man Ray's *Cadeau (Gift)* of 1921 (above) turns an everyday item with a practical function – a clothes iron – into an art object, rendering it entirely non-functional and useless. *Cadeau* was made as a gift for Phillippe Soupault, the owner of the gallery where Man Ray had his first solo Paris exhibition.

CONSTRUCTIVISM

Politically involved and connected with revolutionary concepts in Russia, Constructivism began in that country in 1915. Favouring simple geometric shapes and abstraction, Constructivism was modern and urban. In architecture Constructivism focused on austerity and the use of industrial material. The Russian artist and architect Vladimir Tatlin (1885–1953) designed a *Monument to the Third International* (also known as the Comintern, the organization created to promote global Communism), which has come to be known as Tatlin's Tower (below). Models were built, but the intended full-scale tower building of 400 m (1,300 ft) in St Petersburg, Russia, was not. Tatlin's Tower was to have been constructed of metal and glass – modern industrial materials rather than natural materials such as stone and wood. Like the Eiffel Tower in Paris,

Vladimir Tatlin
Monument to the Third International, 1919–20
Model, intended to be built in St Petersburg, Russia

Tatlin's Tower represents early 20th-century Russian Constructivism, a movement in architecture and art closely linked to the Russian Revolution and political movements. Models are in museums in Stockholm, Moscow and Paris.

Tatlin's Tower was also a huge metal skeletal structure, but Tatlin intended his tower to be even taller. The open central space was to contain suspended geometric-shaped rooms (a cylinder, a pyramid and a cube) each of which served a different purpose and rotated at a different speed. Visually, Tatlin's Constructivist architecture may be seen as a form of abstract art.

Marc Chagall
Violiniste (The Green Violinist),
1923–4
Oil on canvas,
1.98 x 1.09 m
(6 ft 6 in. x 3 ft 7 in.)
Guggenheim Museum,
New York

Chagall gave visual expression to feelings of nostalgia for his earlier life. Although painted in Paris, the setting is his former home town in Russia.

EXPRESSIONISM

Rather than focusing on the actual appearance of the natural world, Expressionist artists use distortion of shape and colour to give visual form to their emotions and thoughts – to express themselves. This approach appears in visual arts, music and literature.

Marc Chagall (1887–1985) was born Moishe Shagal or Segal in the Vitebsk area of Russia, the oldest of nine children in a Hasidic Jewish home. Images from his childhood pervaded his paintings throughout his long life. He moved to St Petersburg to study art. In 1910, at the age of twenty-three, he moved to Paris, learned the language and loved the way of life. His distinctive and very personal style – intentionally awkward and naïve, with its characteristic floating figures – was already formed. Chagall's charming, colourful dream world includes both Jewish and Christian images; he said his art related to the dreams of all of humanity, rather than to any one group of people. His own words give insight into his personality and approach to art: 'If I create from the heart, nearly everything works; if from the head, almost nothing.'

Chagall first painted *The Fiddler* in 1912 (Stedelijk Museum, Amsterdam) and repeated this subject as *Violiniste (The Green Violinist*, opposite) in 1923–4 in Paris. He is known for fantastic images, such as a musician dancing on roofs while a tiny person flies through the sky. The faceted forms are a holdover from Cubism. Chagall's art is romantic and sentimental and includes humorous images. Yet there is also a sense of longing for his former life in Russia, seen here in the setting with small wooden houses.

SURREALISM

Beginning as a literary movement in Paris, Surrealism quickly appeared in painting and sculpture. This intentionally innovative style focused on dreams and fantasy as sources of new subject matter.

The subconscious dream world was combined with the conscious waking world to create a super-realism – a surrealism

Like Dada, Surrealism may be seen as an art of dissatisfaction with contemporary life.

The Spaniard Salvador Dalí (1904–89) is the quintessential Surrealist – both in his art and in his life. Arriving in Paris in 1929, he promoted himself as a Surrealist cult figure through a variety of seemingly irrational, yet carefully calculated behaviours, including the various ways in which he styled his foot-long moustache.

Dalí's painting *Apparition of a Face and a Fruit Dish on a Beach*, 1938 (above), depicts a face, also seen as a fruit dish holding pears. However, those pears are also the spots on the back of a dog seen in profile. And there is much more on this beach. Each item is distinct, painted with a miniaturist's technique, nearly tangibly real. Yet these things exist only in our imagination. Forms have been combined in an impossible way; this creature is part human, part canine, part pear and part landscape. Dalí amalgamates the familiar, the ordinary, in an extraordinary way, creating intentionally unsettling images.

Salvador Dalí
Apparition of a Face and a Fruit Dish on a Beach, 1938
Oil on canvas,
1.15 x 1.44 m
(3 ft 9 in. x 4 ft 9 in.)
Wadsworth Atheneum Museum of Art, Hartford, Connecticut

Combining psychology and art, Surrealist artists sought to express the unconscious. Intentionally enigmatic and mysterious, Dalí's painting depicts the impossible and irrational with absolute conviction.

146

The technical virtuosity makes it difficult to accept Dalí's proclamation that his paintings were produced in a state of psychological delirium, and that he often had no idea of what he was painting until he recovered.

HARLEM RENAISSANCE

Beginning around 1920 and continuing into the 1930s, the Harlem Renaissance was a flowering of African American culture that centred on Harlem, a neighbourhood in northern Manhattan, New York City. Music, dance, sculpture, painting and other creative arts flourished.

The African American sculptor Augusta Savage (1892–1962), born in Florida, one of fourteen siblings in an impoverished family, was nevertheless very well educated. Active in the Harlem Renaissance, she founded the Savage Studio of Arts and Crafts in 1932, where she was an influential teacher.

Savage's large-scale sculpture *The Harp (Lift Every Voice and Sing)*, 1939 (overleaf), was commissioned for the 1939 World's Fair. The song 'Lift Every Voice and Sing' was written by James Weldon Johnson and J. Rosamond Johnson in 1905 to commemorate the birthday of the American President Abraham Lincoln, who issued the Emancipation Proclamation freeing slaves in 1863. Sadly, when the Fair ended, the original figures were destroyed. Much of Savage's sculpture focused on portraits of African Americans.

In addition to her artistic work, Savage was a social activist working to combat racism and to increase the visibility of African American artists. She helped create a strong community that supported many artists, including Jacob Lawrence.

The boom times had bypassed the agricultural sector as demand from Europe dried up. Small farmers, especially share-croppers who were generally former slaves and their descendants, were hard hit, spurring their relocation from south to north in search of industrial work and a better life. Beginning in 1916, several million African Americans participated in the Great Migration.

African American artist Jacob Lawrence (1917–2000), born in Atlantic City, New Jersey, moved to Harlem, where he studied art. Supported by the WPA (Works Progress Administration established by President Franklin D. Roosevelt to increase employment during the Depression), Lawrence's artworks focused on African American subjects. His set of paintings

Augusta Savage
*The Harp (Lift Every
Voice and Sing)*,
1939
Plaster, original destroyed

An image of a harp
is created by figures
of twelve African
Americans singing,
representing the strings
of the harp. A figure of a
man holding sheet music
forms the foot pedal and
the arms of God provide
the soundboard.

Jacob Lawrence
*During the World War
there was a Great
Migration North by
Southern Negros*,
1940–41
Panel 1 from *The Migration
of the Negro*
Series of 60 panels,
casein tempera
on hardboard,
30.5 x 45.7 cm
(12 x 18 in.)
Phillips Collection,
Washington, DC

**This series of images
documents racial
inequality in America.
When exhibited in 1941,
they were lauded as both
historical records and
works of art.**

The Migration of the Negro, created 1939–41 (above), documented African Americans' travels and experiences in their new surroundings.

ARCHITECTURE

In contrast to the great variety of styles that developed during the first half of the 20th century in painting and sculpture, architecture was far more consistent, favouring the International Style. Popular especially in the 1920s, it was distinguished by a preference for modern man-made materials such as reinforced concrete and metal, as opposed to natural wood and stone.

An important International Style architect was Charles-Édouard Jeanneret (1887–1965), known by his pseudonym Le Corbusier, French for 'the crow-like one'. Born in Switzerland, he later became a French citizen. He designed the Villa Savoye in Poissy-sur-Seine, a suburb of Paris (overleaf), built 1928–31, a private home that had an important impact on modern domestic architecture and may be considered architecture's answer to abstract art's compositions of simple geometric shapes. Le Corbusier admired the precise shapes of machinery. His Modernist home is a smooth white box with sharp edges and a band of windows running around the upper floor. The lowest level served functional needs. A spiral ramp, akin to an overgrown sculpture, leads to the living area above.

Here the bands of windows allow residents to look out, and a suspended garden in the centre offers an indoor/outdoor patio. Rather than thick walls of stone, thin poles called **pilotes** provide support. This skeletal structure frees the walls from their supporting role, permits huge windows and opens a door to architectural creativity.

The American architect Frank Lloyd Wright (1867–1959) was born in Wisconsin. Before he was born, his mother, a teacher, determined he would become an architect. Later in life he said that the geometrically shaped Froebel blocks she gave him to play with as a child influenced the geometric shapes of his buildings. Wright considered every project to be an individual problem and refused to repeat his own designs. He believed that the character of each building should relate to its specific site, blending with the natural landscape through the shapes and materials used. Wright termed his theory on harmony between people and their environment 'organic architecture'. In an organic house plan the form was determined by its function. Wright's architecture therefore grew from the inside out. His most famous private home is the Kaufmann House ('Fallingwater') in Bear Run, Pennsylvania, built 1935–9. The wooded property includes a waterfall, and the usual solution to the problem of where to build the house would have been to position it so that the residents have the best view of the waterfall. Wright, however, did the opposite: he built the house literally *over* the waterfall.

Le Corbusier (Charles-Édouard Jeanneret) Villa Savoye, Poissy-sur-Seine, France, 1928–31

Le Corbusier referred to the homes he designed as *machines à habiter* meaning 'machines in which to live'.

Frank Lloyd Wright
Guggenheim Museum,
New York,
construction started
1956, opened 1959

The extraordinary architecture of this museum and others built in recent years makes them destinations in themselves.

Constantly seeking the unique, Wright designed the Solomon R. Guggenheim Museum in New York City (above). Commissioned in 1943, construction began in 1956, and the museum opened in 1959. The extraordinary shape of the Guggenheim, a spiral that is wider at the top than at the bottom, is made possible by reinforced concrete, a material perfectly suited to creating curving forms on a grand scale. Inside, a ramp spirals around an open core. The glass dome above admits light. Wright's intention was that visitors would take the lift to the top, then look at the art while slowly walking down and around the spiral. The Guggenheim Museum appears to be a supersized sculpture in itself.

Later 20th- & early 21st-century art
Is innovation in the visual arts always a good thing?

Germany's attack on Poland in 1939 and Russia in 1941, and Japan's attack on the USA in that year, initiated another multi-national conflict. The Second World War continued until 1945 with terrible loss of life and the devastation of much of Europe. Ultimately the forces of Britain, the USA, France and the USSR defeated

Germany and its major European ally, Italy. The war in the Pacific ended when American atomic bombs destroyed the Japanese cities of Hiroshima and Nagasaki, the use of nuclear weapons adding a new spectre of annihilation to the prospect of global war. The United Nations was formed in 1945 to provide a forum for the resolution of international conflicts.

Immediately following the Second World War, the USA experienced an economic boom and helped western Europe begin reconstruction, in the process becoming the world's major economic and industrial power and spreading its language around the world.

The USSR now had troops throughout eastern Europe, and soon the occupied countries had Communist governments. By March 1946, in the words of Britain's wartime Prime Minister, Winston Churchill, 'an iron curtain [had] descended across the Continent'. The Cold War between, on one side, the USSR and its allies (the Soviet bloc), and on the other, the USA and its allies (the West), had begun. By 1950 the USSR had developed nuclear weapons and the two great powers entered a period of stalemate.

Georgia O'Keeffe
Poppies,
1950
Oil on canvas,
91.4 x 76.2 cm
(36 x 30 in.)
Milwaukee Art Museum,
Wisconsin

Starting from a profound love of nature, O'Keeffe often chose a natural form, usually a flower, seen close up and enlarged to the extent that it approaches an abstract pattern.

AMERICAN MODERNISM

A philosophy that resulted from a changing society, Modernism favours the development of individual artistic style, accomplished by turning away from tradition. Rather than repeating and refining the past, Modernist artists sought new subjects and ways to depict them. Modernism holds that creative, innovative work that is original, even novel, will lead to progress. Modernism extended beyond the visual arts to other art forms.

The American Modernist Georgia O'Keeffe (1887–1986) was born in Wisconsin and studied and taught art in various locations in the USA. She is called an American Modernist for her break with the past and search for new ideas. Known for her depictions of flowers, she said, 'When you take a flower in your hand and really look at it, it's your world for the moment. I want to give that world to someone else.' She developed a personal style of beautiful colour harmonies and smooth shapes that she would maintain for decades. Intrigued by light and colour, she said, 'Colour is one of the great things in the world that makes life worth living to me.' As seen in her *Poppies* of 1950 (opposite), the colours are rich, saturated, splendid and varied. She depicted flowers of many types, lovingly and accurately.

ABSTRACT EXPRESSIONISM

A new approach to art, seen especially in painting, Abstract Expressionism is concerned with individual expression through non-naturalistic images.

-

Often working on a large scale, artists painted in individual and personal styles free of connections with previous approaches

-

A sense of the artist's physical gesture while painting differentiates Abstract Expressionism from abstract art.

The Abstract Expressionist Jackson Pollock (1912–56) was born Paul Jackson Pollock in Wyoming. After being expelled from two high schools, he moved to New York, where he studied painting and

Jackson Pollock
Blue Poles (Number 11), 1952
Enamel and aluminium paint with glass on canvas, 2.11 x 4.85 m (6 ft 11 in. x 15 ft 11 in.)
National Gallery of Australia, Canberra

Time **magazine dubbed Pollock 'Jack the Dripper'.**

worked in a representational style. He abandoned this for his 'drip' paintings, which made him famous. He created these paintings by unrolling the canvas on the floor, hanging buckets of enamel house paint by ropes from the ceiling and swinging them, causing the paint to drip and splash onto the canvas below. Pollock also splattered paint from his brush, and other implements, onto the canvas, working from all four sides.

A work such as *Blue Poles (Number 11)*, 1952 (below), is descriptively referred to as Action Painting because the painting conveys the sense of the artist's physical activity while creating it. Pollock moved his entire body when he painted. For him, the process of getting paint onto the canvas was the most important part of the work. There is no single focal point or area of particular interest, nor is there an obvious top or bottom other than that suggested by the location of Pollock's signature. Instead, the entire

surface is unified by a web of paint formed by building up countless
layers, which may be seen as forces that push and pull, dynamic,
rhythmic and spontaneous. Pollock described these paintings as
'energy and motion made visible'. Eventually, he stopped giving
his paintings titles and instead gave them only numbers and dates,
which are neutral, suggesting nothing to the viewer, and thus
enabling viewers to look at the painting purely for itself.

Abstract Expressionist painters include the African American
Alma Thomas (1891–1978), born in Columbus, Georgia, and active
in Washington, DC, where she taught art in junior high school for
many years. Known for her vividly coloured geometric patterns,
her paintings look like lessons in colour theory. Comparing the
paintings of Thomas to the tightly controlled, precisely executed,
restrained and refined patterns of Canada-born American Agnes
Martin (1912–2004), self-described as an Abstract Expressionist,
makes clear the disparity of styles considered to be Abstract
Expressionism. Martin said, 'Beauty and perfection are the same.'

Pollock was filmed while creating his Action Paintings, which
therefore may render his work a type of Performance Art. This
was a medium that gained popularity in the late 20th century, as
demonstrated by Serbian performance artist Marina Abramović
(b.1946), who gives live performances in which the artist's body
is used creatively.

POP ART

A shortening of Popular Art, this style favoured subjects adapted
from popular culture that would not have previously been considered
worthy of an artist's attention. The American Andy Warhol (1928–
87), born Andrew Warhola in Pittsburgh, Pennsylvania, was the King
of Pop. Although known for his Pop persona and unconventional
lifestyle, in many ways he was very traditional. He spoke the
Carpatho-Rusyn language of his parents and ate the traditional foods
of their culture. His mother lived with him for much of his life. He was
a practising Ruthenian Catholic and described himself as religious.

Fascinated by celebrities, especially movie stars including
Elizabeth Taylor, Marilyn Monroe and Elvis Presley, Warhol
silkscreen-printed public photos of them in vivid colours. He used
immediately recognizable, everyday products such as a box of
Campbell's tomato juice (opposite) and soup cans, Coca-Cola
bottles and dollar bills for his subjects. Although Warhol does not
express an opinion about these products, that does not preclude
meaning; he regarded ordinary, widely available products as social

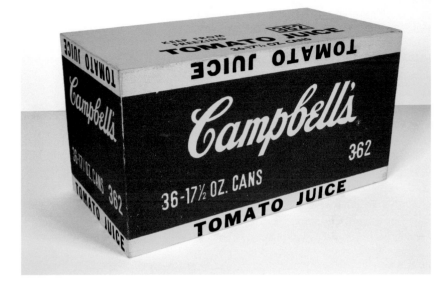

Andy Warhol
*Campbell's Tomato
Juice Box,*
1964
Polymer paint and
silkscreen ink on wood,
25.4 x 48.3 x 24.1 cm
(10 x 19 x 9½ in.)
Museum of Modern Art,
New York

**Pop Art portrays
common commercial
consumer items –
far from the subjects
traditionally found in
fine art. Warhol's images
elevate the ordinary to
artistic status.**

equalizers. He said, 'What's great about this country is that...the
richest consumers buy essentially the same things as the poorest....
A Coke is a Coke and no amount of money can get you a better
Coke than the one the bum on the corner is drinking.'

Other Pop artists include the American Roy Lichtenstein
(1923–97), born in New York City, and Swedish-born American
Claes Oldenburg (b.1929). Lichtenstein is known for his enlarged
comic strips, while Oldenburg is known for his gigantic sculptures
of household items such as a clothes peg or a spoon.

Pop Art images, specific and identifiable, seem to be the
opposite of artists' and art historians' more recent tendencies to
seek the obscure, multiply the adjectives and covet convoluted
complexities in their approaches to art, as may be seen in
Postmodernism, semiotics, deconstruction, and other approaches
that purposely circumvent clarity.

OP ART

The Vietnam War, 1955–75, impacted various aspects of life.
By 1968, for many people in the USA, especially those of university
age, the war had sparked distrust of the government, rejection of
established social norms and increasing turmoil. In Europe much
the same rejection of the established order was in process. This

disillusionment coincided with a quest among artists to find order
in a disordered world; a form of precise control appeared in Op Art.

A shortening of the term Optical Art, Op Art is concerned with
optics. Intellectual rather than emotional, Op Art paintings are
non-representational patterns, precisely painted with hard edges on
areas of often vivid, contrasting colours. Victor Vasarely (1906–97),
a Hungarian-born French artist, was one of the leading figures of
this movement. Vasarely painted with black and white; zebras were
an early subject. He began applying colours to geometric grid-
based designs in the 1960s. In *Vega-Nor*, 1969 (opposite), a grid
of presumably horizontal and vertical lines appears to bulge out
towards the viewer, the illusion achieved by systematically altering
the dimensions of the squares, effectively implying three dimensions
on a two-dimensional surface without using the customary devices
to do so; the lines here are not used as in linear perspective.
Although non-figurative, Op Art may suggest movement.

Other important Op Art artists are the British painter Bridget
Riley (b.1931) and the American painter Richard Anuszkiewicz
(1930–2020).

Vasarely used a computer to help create his later Op Art
images. The 1960s and 1970s were a period of rapid technological
development, seen in the large-scale application of computers
to business problems and the development of mobile phones,
personal computers and social networking. The first commercial
mobile phone networks appeared in Europe in 1972. With ease of
communication came increasing economic globalization.

CONCEPTUAL ART

In Conceptual Art the idea – the concept – is more important than
the actual finished work. Many artists and styles may be described
as conceptual, but especially characteristic is the American Sol
LeWitt (1928–2007). Known for his wall drawings, LeWitt created
instructions which were then executed by assistants. Thus different
people, following LeWitt's words, could create the work in more
than one location. For example, his *Wall Drawing 289*, designed in
1976, using white crayon lines and a black pencil grid on black walls,
has been drawn on the walls of several museums. Other examples
of this approach are Fluxus, an international group of artists and
other creatives active in the 1960s and 1970s, as well as the YBAs
(Young British Artists), beginning in the late 1980s, and including
Damien Hirst.

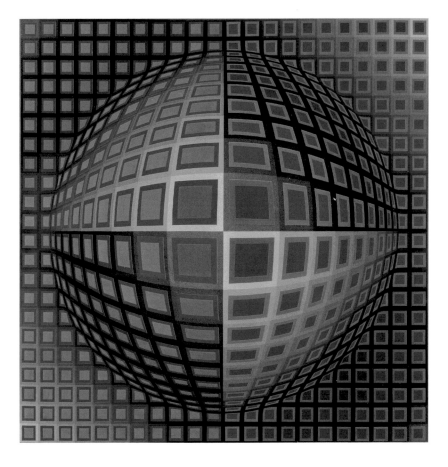

Victor Vasarely
Vega-Nor,
1969
Acrylic on canvas, 2 x 2 m
(6 ft 6 in. x 6 ft 6 in.)
Albright-Knox Art
Gallery, Buffalo, New York

**Optical Art plays
tricks with our vision,
mesmerizing our eyes.**

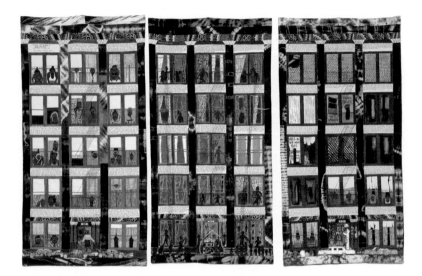

SOCIALLY ENGAGED ART

Key to race relations in the USA was the 1954 landmark decision
by the Supreme Court known as Brown vs Board of Education,
which outlawed racial segregation in public schools throughout
the country and marked a major step in the struggle with racism.
In 1964, the Civil Rights Act outlawing discrimination based on
'race, colour, religion, sex, or national origin' was passed.

Artists began creating work that engaged with issues of social
justice. The multi-talented African American artist and activist
Faith Ringgold (b.1930), born in Harlem, creates art that deals
with racism and feminism. She stated, 'No other creative field
is as closed to those who are not white and male as is the visual
arts.' Ringgold is known for her story quilts (above) that convey
messages. She learned to quilt using techniques passed down in her
family. The stories on her quilts are the equivalent of publications
when hung in public places. During a long career she has worked in
a variety of other media, including painting, sculpture, children's
books, masks and performances.

Other artists with related interests in racial injustice
and gender equality include Betye Saar (b.1926), who uses
assemblages to tell her stories, and Kara Walker (b.1969), who
creates striking silhouettes cut from black paper. Her 2014
installation *A Subtlety, or The Marvelous Sugar Baby*, is a 10.7 m

Faith Ringgold
Street Story Quilt,
1985
Cotton canvas, acrylic
paint, ink marker, dyed
and printed cotton
and sequins, sewn to a
cotton flannel backing,
overall 2.29 x 3.66 m
(7 ft 6 in. x 12 ft)
Metropolitan Museum
of Art, New York

**The quilts are Ringgold's
autobiography, akin to
a diary. Their stories are
intimately related to
the events around her
own life as an African
American.**

(35 ft) tall sugar-coated styrofoam image of a sphinx-like African woman.

ENVIRONMENTAL ART

This relatively new category for creativity is linked to the growing concern for nature and the environment. In the late 20th and early 21st centuries, attitudes to the human impact on the environment changed, reflecting recognition of climate change and global warming.

While there has long been an interest among artists in depicting aspects of nature, Environmental Art, in contrast, actually uses parts of nature to create art. The British sculptor Andy Goldsworthy (b.1956) does not make his works specifically to effect environmental change, but rather to draw attention to forces of nature which can be overlooked, accomplished by the ingenious use of natural materials to celebrate their intrinsic beauty. With a keen aesthetic sensibility, he sees potential in ordinary materials which, when relocated, combined and multiplied become fine art sculpture. Many of the materials Goldsworthy uses, such as the tree limb in *Wood Through Wall*, 1993 (below), are ephemeral, destined to eventually decay and return to the earth. This applies also to his work with leaves and flowers. Other works constructed of stone are more permanent.

Andy Goldsworthy
Wood Through Wall
(detail),
1993
Collection of Sherry and
Joel Mallin, Pound Ridge,
New York

**A work like this is a
site-specific installation,
created solely for this
location, a unique one-of-
a-kind piece impossible
to repeat exactly
anywhere else.**

Artists with related interests in Land Art include the American Robert Smithson (1938–73), important for his large-scale works such as *Spiral Jetty*, 1970, and the British sculptor Richard Long (b.1945), known for his installations such as *White Water Line*, 1990.

PUBLIC ART

Where do you draw the line between **graffiti**, **Street Art** and **Public Art**? Granted, the term 'graffiti art', used today, may sound like an oxymoron. The word **graffiti** comes from the Italian *graffito*, meaning 'scratch', and refers to words and images on walls in public places. Graffiti, done without permission from the owner of the wall is, in fact, vandalism and thus a crime.

Street Art, in contrast to graffiti, is more likely to be created on walls by people trained as artists. Perhaps the most famous street artist today is the anonymous artist known only as Banksy. His work on walls is not done with permission and, consequently his identity is a carefully guarded secret. Although British, he has worked on walls worldwide. Banksy is clever and witty, but also takes on

Louise Bourgeois
Maman (Mother),
1999, cast 2003
Stainless steel,
bronze, marble,
9.27 x 8.91 x 10.24 m
(30 ft 5 in. x 29 ft 3 in.
x 33 ft 7 in.)
National Gallery of
Canada, Ottawa

**Art is for everyone.
In front of the museum,
very large and visible, is
one of the six *Maman*
spiders Bourgeois
created. They are now
found worldwide.**

serious issues. He stencilled an image of Steve Jobs (co-founder of Apple) as *The Son of a Migrant from Syria* on the wall of the migrant encampment in Calais, France.

Public Art is likely to be created on commission, to be site-specific, and to be designed with regard to its eventual location.

-

Public art is intended to embellish, enhance or add interest to a location and may be permanent or only temporary

-

Important concerns are the durability and maintainability of the materials used, because both Mother Nature and human nature are inclined to cause damage. An example is the huge spider by Louise Bourgeois, *Maman*, 1999, cast 2003 (opposite), the title explained by the artist's belief that spiders protect us. This was made in homage to the artist's mother.

Among those who have created Public Art are the American sculptor Alexander Calder (1898–1976), Russian-born American Louise Nevelson (1899–1988) and the duo Christo (1935–2020) and Jeanne-Claude (1935–2009), Bulgarian and French, respectively.

FEMINIST ART

The prominence of women in the art world has increased significantly in recent years. In the 1970s, only ten percent of solo exhibitions of living artists were of the work of women. As late as 1982, the Coalition of Women's Art Organizations reported that only two percent of museum exhibitions by living artists were allotted to women. According to *Smithsonian* magazine, 'between 2008 and 2018, artwork by women represented 11% of acquisitions and 14% of exhibitions at 26 major [American] museums'.

The need for greater female representation in the art world is the focus of a group of women known as the **Guerrilla Girls** – a reference to guerrilla warfare – who keep their identity hidden by their gorilla masks (overleaf). Beginning in 1985, they plastered New York City with posters publicly questioning the inequality with which women are represented, exhibited and funded in the arts.

Feminist artists include Canadian-born Miriam Schapiro (1923–2015), who created 'femmages' – collages of fabric.

Guerrilla Girls
Benvenuti alla biennale
femminista! (Welcome
to the feminist biennale!)
from the series 'Guerrilla
Girls Most Wanted:
1985–2006',
2005
Lithographic poster,
43.7 x 28.5 cm
(17¼ x 11¼ in.)
National Museum of
Women in the Arts,
Washington, DC

**Using humour and
documented irrefutable
facts and statistics, the
Guerrilla Girls have
advanced the position of
women in the art world.**

The American Judy Chicago (b.1939), born Judy Cohen, working with many other women, created *The Dinner Party*, a large mixed-media sculpture, 1974–9. At a triangular table, each of the thirty-nine place settings represents a specific woman. Arranged for thirteen people on each side, this recalls depictions of Jesus's Last Supper. The *Dinner Party* is a monument to the myriad accomplishments of women through the ages. Permanently installed in the Brooklyn Museum of Art, New York, in 2002, it is an example of Installation Art, which is three-dimensional and requires the spectator to move around or through the work.

DIGITAL ART

A fresh addition to the artists' repertoire of tools and technique is Digital Art, also called Computer Art, which utilizes technology to create or display a work of art. Digital artists include the Canada-born university professor and author Margot Lovejoy (1930–2019) and the Australia-born creator of experimental computer-generated images David McLeod (b.1960). Video Art also depends on technology, combining various moving images with sound, as seen in the work of the American multi-media artist Bruce Nauman (b.1941) and the Swiss experimental video artist Pipilotti Rist (b.1962).

RECENT ARCHITECTURE

Later 20th- and early 21st-century architects actively sought innovation in design to meet evolving needs, using newly available materials and computer-aided construction methods to create seemingly impossible structures.

Among the most notable examples of internationalization in an architect's personal life and work is Zaha Hadid (1950–2016). She was born in Iraq into a wealthy, politically liberal family, and her mother was an artist. Educated in a variety of countries including England, she became a British citizen. Her London-based firm, Zaha Hadid Architects, has created projects in forty-four countries. She is known for futuristic architecture of extremely complex, unexpected, unusual, asymmetric shapes such as the Pabellón Puente (Bridge Pavilion) in Zaragoza (overleaf).

When public museums were first introduced in the late 18th century, pre-existing buildings such as palaces (the Hermitage in St Petersburg, or the Louvre in Paris) or large homes were opened to allow the public access to previously private collections. The

purpose-built museum, however, could be entirely unique. Recent
notable examples include the pyramidal entrance to the Musée
du Louvre, Paris, designed 1988–9 by the Chinese architect
I. M. Pei. For the Milwaukee Art Museum, Wisconsin, the Spanish
architect and engineer Santiago Calatrava designed extraordinary
huge moving wings in 1994, completed in 2001. Very different in
appearance is the Whitney Museum of American Art, New York,
designed 2007–15 by the Italian architect Renzo Piano, with
stacked geometric shapes.

Canadian-born American architect Frank Gehry (b.1929), born
Frank Owen Goldberg, has been dubbed a 'starchitect' because
of his celebrity status. His Guggenheim Museum in Bilbao, Spain,
built 1992/1993–7, features shiny titanium walls that appear
to have been gently bent, as if supple, almost fluid. The visitor
may wonder if this is sculpture as architecture, or architecture
as sculpture. The division between two traditionally distinct
disciplines has been blurred. Is the art only inside the museum,
or is it the museum itself?

Gehry's Biomuseo in Panama City, Panama (opposite),
completed in 2019, is a natural history museum of biodiversity
containing exhibits about Panama's history going back three
million years. Unlike Gehry's usual preference for nearly
monochromatic buildings, the vivid colours selected for the
Biomuseo relate to Panama's own colourful plants. Typical of
Gehry, however, are the unusual shapes, recalling the many
folds of origami.

Zaha Hadid
Pabellón Puente (Bridge
Pavilion), Zaragoza,
2005–8
Fibreglass reinforced
concrete, total length
280 m (919 ft)

**This enclosed multi-level
pedestrian footbridge
over the River Ebro was
built as an exhibition area
and a gateway to Expo
2008 in Zaragoza. When
designed by the Queen
of Curves, as Hadid is
known, architecture
undulates.**

Frank Gehry
Biomuseo,
Panama City, Panama,
partly opened 2014,
completed 2019

**Inside, appropriately for
the building's function as
a biodiversity museum,
the ceiling supports
mimic tree trunks with
spreading branches.**

KEY IDEAS

Romanticism: Emotional art reacts to political upheavals.

Realism: Painters portray everyday subjects in a
non-idealized way.

Impressionism: Artists depict their immediate surroundings
with a focus on light and colour.

Post-Impressionism: Artists seek to express a more personal
interpretation of subjects.

20th and early 21st centuries: A multitude of rapidly changing
and simultaneous styles reflect the complexity of political
power and reaction to the destruction of warfare. Globalization
is fostered by the increasing facility with which ideas are
disseminated. The harmful effects of climate change are
gradually recognized.

GLOSSARY

Ambulatory: in architecture, a walkway around the interior of a church or cathedral.

Amphora: ancient Greek two-handled vase.

Angle contraction: in architecture, especially Greek temples, placement of the columns towards the corners of a building closer together than the other columns on the four sides.

Animal style: designs created from unidentifiable, often serpentine, animals, their bodies elongated and interlaced.

Apse: see **Christian church, parts**.

Atmospheric (aerial) perspective: painting technique used to create an illusion of depth by recording the natural phenomenon in which the atmosphere diminishes the perceived clarity of forms and colours in the distance.

Atrium: see **Christian church, parts**.

Barrel (tunnel) vault: in architecture, a simple vault formed by a continuous series of rounded arches.

Black-figure vase painting: ancient Greek technique in which the figures are painted black and details are incised.

Broken colour: Impressionist painting technique in which each colour is made up of little dabs of its component colours.

Central plan: in architecture, a circular or polygonal building.

Chiaroscuro: Italian for 'light and dark', painting technique emphasizing light and shadow.

Christian church, parts: in architecture, the **atrium** is an open forecourt; the **narthex** is an entry vestibule; the **nave** is a large rectangular space flanked by aisles; the **transept** is the section at right angles to the nave; the semi-circular **apse** concludes the structure.

Clerestory (clearstory): in architecture, the uppermost storey with windows.

Coffers: in architecture, squarish indentations on the underside of an arch or dome.

Colossal order: in architecture, also called giant order, a column that extends in front of two or more stories, visually linking them.

Contrapposto: a pose in which the weight is on one leg, raising that hip and the opposite shoulder, putting the spine into an S-curve.

Corinthian: ancient Greek architectural order characterized by curling acanthus leaves on the column capitals.

Cromlech: circle of **menhirs**.

Cross (groin) vaults: two barrel vaults intersecting at right angles.

Doric: ancient Greek architectural order characterized by the block-shaped abacus and the cushion-shaped echinus on the column capitals.

Entasis: in architecture, the bulge in the middle of a column.

Fan vaulting: in architecture, a descriptive term for a type of vault in which the radiating ribs resemble an open fan.

Golden Section: an ideal ratio in which the smaller is to the larger as the larger is to the whole.

Graffiti, Street Art and **Public Art:** graffiti refers to words and images created on walls in public places without permission; **street art** is similar but is more likely to be created by trained artists; **public art** is commissioned and exhibited publicly.

Greek cross plan: in architecture, a building with four arms of approximately the same length.

Groin vault: see **cross vault**.

Guerrilla Girls: a group of women with their identities hidden by gorilla masks who advocate equal representation of women in the art world.

Hip-shot pose: literal description of a pose frequently found in Gothic depictions of Mary, in which her hip juts out to support the infant Jesus.

Icon: a religious image intended to aid the faithful in prayer but not to be worshipped itself.

Iconoclasts: those who opposed the use of images in worship.

Iconophiles: those who favoured the use of artistic images in worship.

Illuminations: detailed illustrations in medieval manuscripts.

Impasto: thick paint applied to a surface.

Ionic: ancient Greek architectural order characterized by the volute-shaped column capitals.

Koré (plural, **korai**): a large, standing Greek statue of a clothed woman.

Kouros (plural, **kouroi**): a large, standing Greek statue of a nude man.

Latin cross plan: in architecture, a building with one long arm.

Machicolations: openings at the top of a wall through which stones and unappealing substances were dropped on unwanted visitors.

Mandorla: a pointed oval of light, often surrounding Jesus on Romanesque tympana.

Manuscripts: books hand-written on animal skin.

Megalith: a huge stone.

Menhir: a **megalith** set vertically into the earth.

Mummification: Egyptian method of preserving the body of the deceased for burial.

Narthex: see **Christian church parts**.

Nave: see **Christian church parts**.

Oculus: in architecture, a circular opening or window.

Orders: in architecture, the style of a building as determined by the type of columns. See **Doric, Ionic, Corinthian.**

Pendant vaults: in architecture, an extreme form of **fan vaulting** with hanging central bosses.

Pendentives: in architecture, masonry in the form of curved triangular sections of a spherical surface that creates a transition between a square base and a circular dome.

Peristyle: in architecture, a colonnade surrounding a building.

Pietà: meaning 'pity', an image of Mary mourning over her dead son Jesus in her lap.

Pilgrimages: long journeys undertaken to visit religious sites in order to worship relics.

Pilotes: in architecture, thin supporting poles.

Polyptych: a work of art consisting of many panels, such as a large altarpiece.

Post and lintel: in architecture, a construction method in which vertical posts support horizontal lintels.

Poussinistes: those who prefer a style of line and calm, exemplified by the paintings of Nicolas Poussin, as opposed to the ***Rubénistes,*** who prefer the colour and emotion of the paintings of Peter Paul Rubens.

Public art: see **Graffiti, Street Art, Public Art**

Readymades: art made from existing objects that are modified and reused in a context for which they were not intended.

Red-figure vase painting: ancient Greek technique in which the spaces between the figures are painted black and details are painted with a tiny brush.

Register system: Egyptian system of organizing subjects depicted in painting and relief into horizontal bands, as on a tomb wall.

Relics: physical mementoes of important religious people, some believed to perform miracles.

Relief sculpture: sculpture in which the figures are attached to the background.

Relieving triangle: in architecture, the triangular space above the doorway lintel intended to relieve pressure on the lintel.

Rose (wheel) window: circular window.

Rubénistes: see ***Poussinistes***.

Scriptorium: Latin for 'place for writing', room in a monastery where manuscripts were written and illuminated.

Sfumato: from the Italian for 'smoke', painting technique using softened outlines.

Stele: slab of stone set vertically into the earth.

Street art: see **Graffiti, Street Art, Public Art..**

Symbolism: see **Synthetism.**

Synthetism: painting style named by Paul Gauguin, characterized by sharply edged areas of flat vivid colours. Because this style was used to translate abstract ideas into visual forms, it is also known as **Symbolism.**

Tenebrism: from the Italian for 'dark', painting technique using bright light to direct attention to the most important parts of a scene while dark shadows obscure all else.

Tesserae: small cubes of coloured material pressed into wet plaster to create a mosaic. The term derives from the Greek word for 'four' because of the four visible corners of the cubes, although tesserae may be other shapes.

Transept: see **Christian church, parts**.

Triforium (gallery): in architecture, the storey between the nave arcade and the **clerestory**.

Tunnel vault: see **barrel vault**.

Tympanum (plural **tympana):** the semi-circular area above a doorway.

Voussoirs: wedge-shaped stones that make up a true arch.

FURTHER READING

Benton, Janetta Rebold, *How to Understand Art* (Thames & Hudson, London and New York, Art Essentials series, 2021)

Benton, Janetta Rebold and Robert DiYanni, *Arts and Culture: An Introduction to the Humanities* (Pearson/Prentice Hall, Upper Saddle River, NJ, 2012)

Bird, Michael, *100 Ideas that Changed Art* (Lawrence King Publishing, London, 2019)

Cheshire, Lee, *Key Moments in Art* (Thames & Hudson, London and New York, Art Essentials series, 2018)

Farthing, Stephen (ed.), *Art: The Whole Story* (Thames & Hudson, London, 2018)

Gormley, Antony, and Martin Gayford, *Sculpture: Shaping the World from Prehistory to Now* (Thames & Hudson, London and New York, 2020)

Hall, Marcia B., *The Power of Color: Five Centuries of European Painting* (Yale University Press, New Haven, CT, 2019)

Hockney, David and Martin Gayford, *A History of Pictures: From the Cave to the Computer Screen* (Thames & Hudson, London, 2016)

Kemp, Martin, *Art History 600 BC–2000 AD* (Profile Books, London, Ideas in Profile series, 2014)

Koeppe, Wolfram (ed.), *Making Marvels: Science and Splendor at the Courts of Europe* (The Metropolitan Museum of Art, New York, NY, exh. cat., 2019)

Reilly, Maura (ed.), *Women Artists: The Linda Nochlin Reader* (Thames & Hudson, London and New York, 2015)

Wilson, Matthew, *Symbols in Art* (Thames & Hudson, London and New York, Art Essentials series, 2020)

Zaczek, Iain (ed.), *A Chronology of Art: A Timeline of Western Culture from Prehistory to the Present* (Thames & Hudson, New York, NY, 2018)

PICTURE ACKNOWLEDGEMENTS

l left r right

2 Wadsworth Atheneum Museum of Art, Hartford, CT. © Salvador Dalí, Fundació Gala-Salvador Dalí, DACS 2022; **4** Centre Guillaume le Conquérant, Bayeux, France; **8** Egyptian Museum, Cairo; **10** Urgeschichtliches Museum, Blaubeuren, University of Tübingen, Germany. Photo Hilde Jensen; **11** Heritage Images/Fine Art Images/akg-images; **12** Matt Cardy/Stringer/Getty Images; **14, 15** Musée du Louvre, Paris; **16** British Museum, London. The Trustees of the British Museum; **17** Egyptian Museum, Cairo; **18** Nikolay Vinokurov/Alamy Stock Photo; **19** Museum of Fine Art, Boston. Harvard University—Boston Museum of Fine Arts Expedition; **20** Metropolitan Museum of Art, New York. Rogers Fund, 1915; **21** Neues Museum, Berlin. Adam Eastland/Alamy Stock Photo; **22** Allard Pierson, University of Amsterdam, APM15770; **24** Metropolitan Museum of Art, New York. Fletcher Fund, 1934; **26** Photo Janetta Rebold Benton; **27** Bildarchiv Monheim GmbH/ Alamy Stock Photo; **28, 29** Staatliche Antikensammlungen und Glyptothek, Munich; **31** Museo Archeologico Nazionale, Naples. Adam Eastland/Alamy Stock Photo; **32** Galleria degli Uffizi, Florence. Photo Scala, Florence; **33** akg-images/Nimatallah; **34** imageBROKER/ Peter Seyfferth/Getty Images; **37** Ministero della Cultura, Parco Archeologico del Colosseom, Rome; **38** Staatliche Antikensammlungen und Glyptothek, Munich; **39** Erin Babnik/Alamy Stock Photo; **40** Ronald Paras/EyeEm/Getty Images; **42** Angelo Hornak/Alamy Stock Photo; **44** San Vitale, Ravenna; **46** Photo Scala, Florence; **47** akg-images; **49** San Vitale, Ravenna; **50** Stefania Barbier/Alamy Stock Photo; **53** Saint Catherine's Monastery, Mount Sinai, Egypt; **54** Trinity College Library, Dublin, MS. A. I; **57** Cologne Cathedral. Photo Winfrid Kralisch; **58** Ed Buziak/Alamy Stock Photo; **59** Manuel Cohen/Scala, Florence; **60** Marshall Ikonography/Alamy Stock Photo; **61** Hervé Champollion/akg-images; **62** Centre Guillaume le Conquérant, Bayeux, France; **63** Album/Oronoz/Album Archivo/SuperStock; **64** Rauner Library, Dartmouth College, Hanover, NH, Ms. Codex 003103; **66** Mistervlad/Shutterstock; **67** akg-images/Bildarchiv Monheim; **69** Sainte-Chapelle, Paris; **70** Godong/Alamy Stock Photo; **71** Rheinisches Landesmuseum, Bonn; **73** John Michaels/Alamy Stock Photo; **74** Scrovegni Chapel, Padua; **76** Musée du Louvre, Paris; **78** Marc Scott-Parkin/Shutterstock; **81** Galleria degli Uffizi, Florence; **82** Musée du Louvre, Paris; **83** Musée du Louvre, Paris; **85** Apostolic Palace, Vatican City; **86** akgimages/Andrea Jemolo; **87** Metropolitan Museum of Art, New York. Gift of Harry G. Friedman, 1960; **88** agefotostock/Alamy Stock Photo; **90** Gallerie Nazionale d'arte antica, Palazzo Barebini Rome. Gallerie Nazionali di Arte Antica, Roma (MIBACT) - Bibliotheca Hertziana, Istituto Max Planck per la storia dell'arte/Enrico Fontolan; **92** Kunsthistorisches Museum, Vienna; **93** DEA/G. DAGLI ORTI/Getty Images; **94** Bailey-Cooper Photography/Alamy Stock Photo; **96** irisphoto1/Shutterstock; **97** Pinacoteca Vaticana, Vatican City; **98** Detroit Institute of Art, Detroit. Gift of Mr. Leslie H. Green; **99** Sant' Ignazio Rome. akg-images/Andrea Jemolo; **100** Musée du Louvre, Paris. Photo Josse/Bridgeman Images; **102** Mauritshuis, The Hague; **103** National Gallery, Prague, 0 2870. Photo National Gallery Prague 2021; **105** State Hermitage Museum, Saint Petersburg. Photo Scala, Florence; **106** Photo Myrabella/Wikimedia Commons; **107** Photo Sampson Lloyd; **108** National Gallery of Art, Washington D.C. Chester Dale Collection; **110** Museum of the History of France, Versailles; **112** National Gallery, London; **113** The Art Institute Chicago. Gift of Thomas F. Furness in memory of William McCallin McKee; **114** National Gallery, London; **115** Musée du Louvre, Paris; **116** State Capitol, Richmond, Virginia; **117** © Anthony Shaw/Dreamstime; **118** National Gallery, London; **120** Museo del Prado, Madrid; **122** Musée du Louvre, Paris; **123** National Gallery, London; **124** Musée d'Orsay, Paris; **126** National Gallery of Art, Washington. Patrons' permanent fund; **127** Musée Marmottan Monet, Paris; **128** Musée d'Orsay, Paris; **130** Los Angeles County Museum of Art. Mrs. Fred Hathaway Bixby Bequest (M.62.8.14); **131** Philadelphia Museum of Art. Bequest of Jules E. Mastbaum, 1929; **132** Courtauld Gallery, London; **134** Pushkin Museum of Fine Arts, Moscow; **135** Private Collection; **136** Barnes Foundation, Philadelphia. Photo Barnes Foundation/Bridgeman Images. © Succession H. Matisse/DACS 2022; **138** Guggenheim Museum, New York; **139** Museum of Modern Art, New York. © Succession Picasso/DACS, London 2022; **141** Guggenheim Museum, New York. Fine Art Images/VG-Bild-Kunst Bonn/Diomedia. © ADAGP, Paris and DACS, London 2022; **142** Cleveland Museum of Art. Delia E. Holden Fund 2011.198. © Man Ray 2015 Trust/DACS, London 2022; **143** Vladimir Tatlin, Monument to the Third International, 1920. Wood and metal, height 4.2m (13' 8 3/8 ft), **145** Guggenheim Museum, New York. The Solomon R. Guggenheim Foundation/Art Resource, NY/Scala, Florence. © ADAGP, Paris and DACS, London 2022; **146** Wadsworth Atheneum Museum of Art, Hartford, CT. © Salvador Dalí, Fundació Gala-Salvador Dalí, DACS 2022; **148** New York World's Fair 1939–1940 records, Manuscripts and Archives Division, The New York Public Library, Astor, Lenox and Tilden Foundations; **149** Phillips Collection, Washington D.C. © The Jacob and Gwendolyn Knight Lawrence Foundation, Seattle/Artists Rights Society (ARS), New York and DACS, London 2022; **150** Bildarchiv Monheim GmbH/Alamy Stock Photo; **151** Image Professionals GmbH/Alamy Stock Photo; **152** Milwaukee Art Museum. Gift of Mrs. Harry Lynde Bradley M1977.133 Photo John R. Glembin. © Georgia O'Keeffe Museum/DACS 2022; **154** National Gallery of Australia, Canberra. © The Pollock-Krasner Foundation ARS, NY and DACS, London 2022; **157** Museum of Modern Art, New York. Museum purchase and partial gift of The Andy Warhol Foundation for the Visual Arts, Inc. Photo Bridgeman Images. © 2022 The Andy Warhol Foundation for the Visual Arts, Inc./Licensed by DACS, London; **159** Albright-Knox Art Gallery, Buffalo, New York. Albright Knox Art Gallery/Art Resource, NY/Scala, Florence. © ADAGP, Paris and DACS, London 2022; **160** Metropolitan Museum of Art, New York. The Metropolitan Museum of Art/Art Resource/Scala, Florence. © Faith Ringgold/ARS, NY and DACS, London, Courtesy ACA Galleries, New York 2022; **161** Collection of Sherry and Joel Mallin, Pound Ridge, NY. Courtesy Galerie Lelong & Co.; **162** National Gallery of Canada, Ottawa. Ulana Switucha/Alamy Stock Photo. © The Easton Foundation/VAGA at ARS, NY and DACS, London 2022; **164** National Museum of Women in the Arts, Washington DC. Courtesy www.guerillagirls.com; **166** View Pictures/SuperStock; **167** Photo Fernando Alda

-

For Theodore, Adam, Elias, Lillian and James

With sincere gratitude to Elliot Benton, Antonia Claire Benton, MBBChir, MA (Cantab), Dr Nona C. Flores, Dr Stephen Lamia and Prof. Vera Manzi-Schacht

-

First published in the
United Kingdom in 2022 by
Thames & Hudson Ltd, 181A High
Holborn, London WC1V 7QX

First published in the United States
of America in 2022 by
Thames & Hudson Inc., 500 Fifth
Avenue, New York, New York 10110

The History of Western Art © 2022
Thames & Hudson Ltd, London
Text © 2022 Janetta Rebold Benton

Design by April

British Library Cataloguing-in-
Publication Data
A catalogue record for this book is
available from the British Library.

Library of Congress Control
Number 2022931877
ISBN 978-0-500-29665-3
Printed and bound in China by
Toppan Leefung Printing Ltd

Front cover: Eugène Delacroix, *The Twenty-Eighth of July; Liberty Leading the People*, 1830 (detail from page 122). Musée du Louvre, Paris

Title page: Salvador Dalí, *Apparition of a Face and a Fruit Dish on a Beach*, 1938 (detail from page 146). Wadsworth Atheneum Museum of Art, Hartford, Connecticut. © Salvador Dalí, Fundació Gala-Salvador Dalí, DACS 2022

Page 4: *Death of Harold, Bayeux Tapestry*, late 11th century (detail from page 62). Centre Guillaume le Conquérant, Bayeux, France

Chapter openers: page 8 *Palette of Narmer*, c.3100 BCE (detail from page 17). Egyptian Museum, Cairo; **page 45** *Justinian and Attendants*, San Vitale, Ravenna, c.547 (detail from page 49). San Vitale, Ravenna; **page 76** Leonardo da Vinci, *Madonna and Child with Saint Anne*, c.1503–19 (detail from page 83). Musée du Louvre, Paris; **page 118** J. M. W. Turner, *Rain, Steam and Speed – The Great Western Railway*, exhibited 1844, perhaps painted earlier (detail from page 123). National Gallery, London